PSYCHIC IMPRESSIONIST PAINTINGS

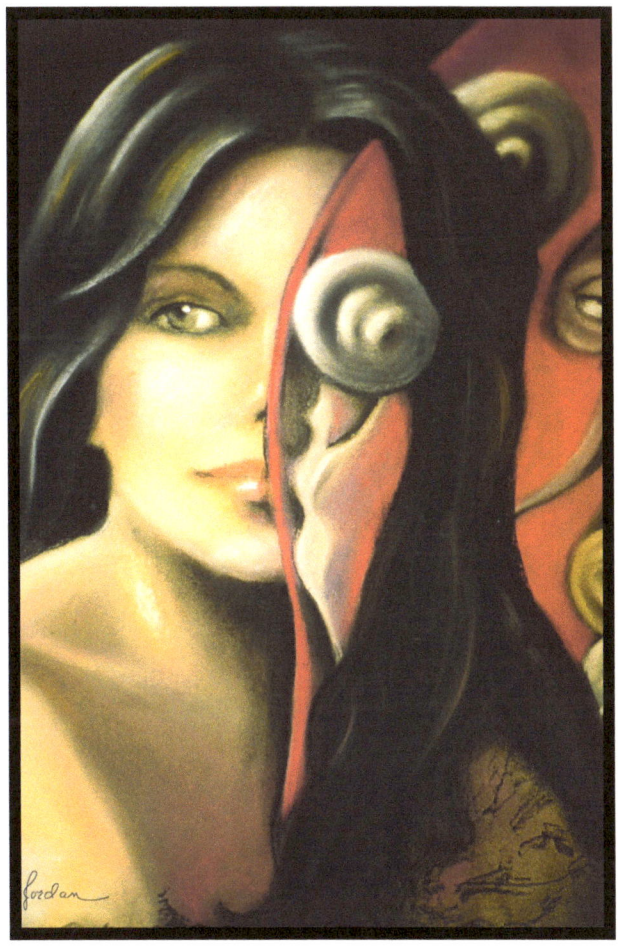

(PAINTING "THE PSYCHIC")

BY SANDRA G. JORDAN

A TRUE VISIONARY ARTIST, SANDRA G. JORDAN USES HER PSYCHIC ABILITY TO EXPLORE THE INNER WORLDS OF THE SPIRIT AS WELL AS THE UNIVERSAL ENERGIES TO BRING US VISIONS OF TRUTH WISDOM AND BEAUTY.

All paintings under copyright by
Sandra G, Jordan
www.newappleproductions.com
website
www.jordanaco.com
jordanaco@aol.come

WELCOME TO JORDAN'S ART BY DESIGN
Psychic Expressionist
Traditional - Abstracts - Impressionist - Surreal - Fantasy - Visionary - Spiritual

Jordan's surreal visionary paintings are sensual and illuminating. As I visited each painting, I found I was swept away into her world and I wanted to stay there on and on" JD Steenburden,

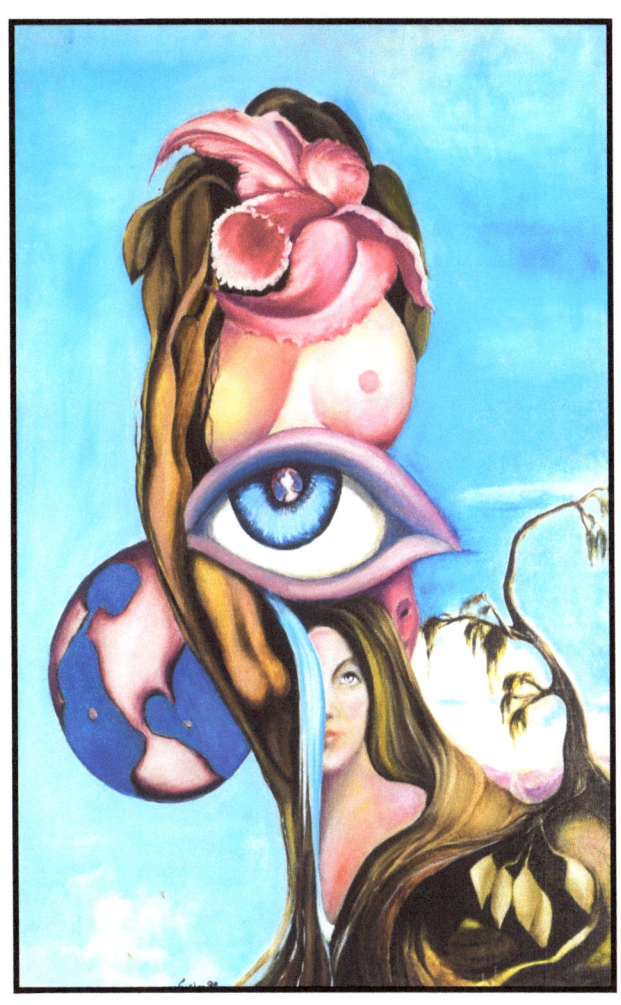

"MY WORLD"
Oil on canvas 30X40"

Step into the creative world of Jordan and experience the magic. Critic's say Jordan's paintings begin where Georgia's left off! Reincarnation! Perhaps?

The magnificent orchid! Try really seeing an orchid. As I stared at it's beauty, the colors shifted, changing before my eyes. I couldn't mix the paints fast enough and move the brush quickly enough to capture a smidgen of the flowing colors.. Three months of seeing and blending and changing the orchid until it finally became "The Orchid".

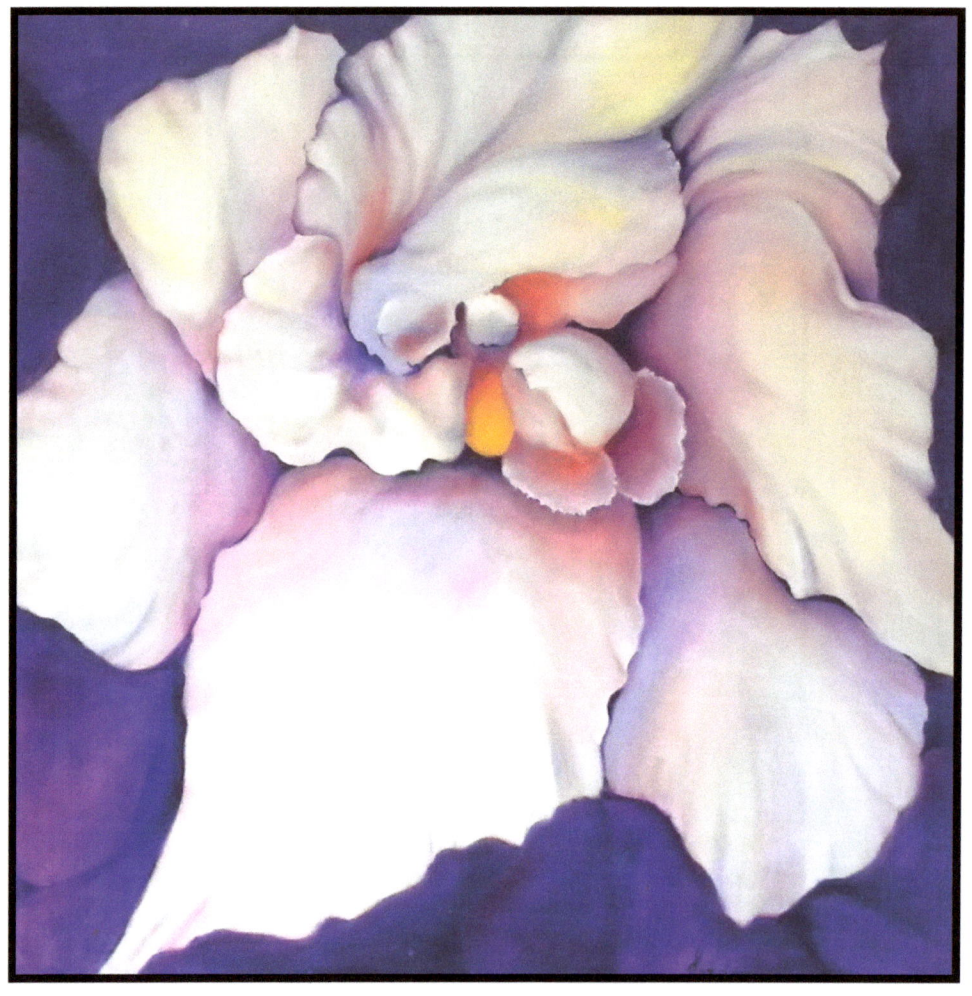

"THE ORCHID" Oil on canvas 28X28"

When I paint a flower, I always sense the unique energy within that flower, thus in order to paint that flower I must become that flower.

"SHEER BLISS" Oil on linen 40X40"

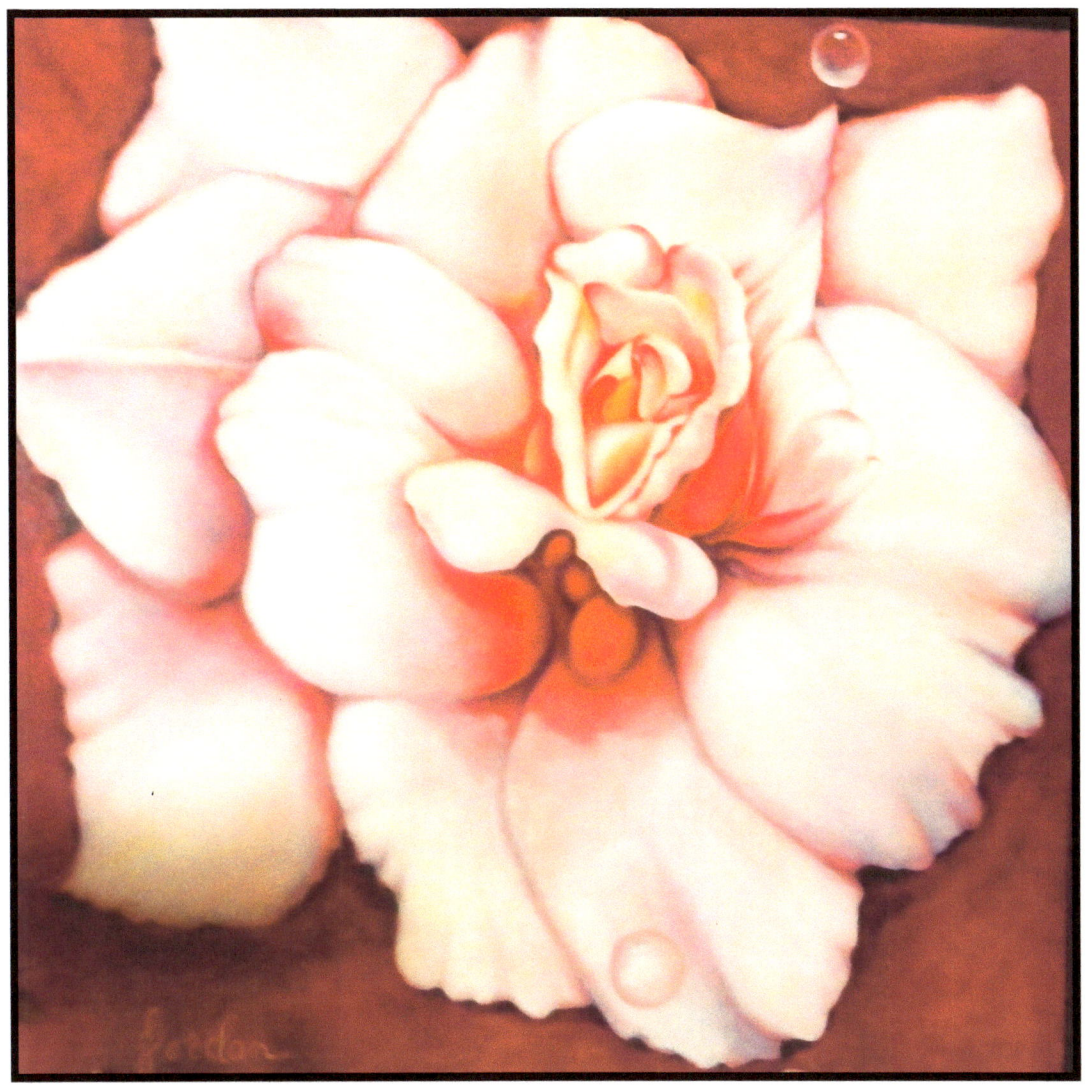

When I first viewed the magnificent rose, 'Sheer Bless'. I felt drawn into the core of the bloom as if being enveloped in a warm embrace. Painting the flower took over my life….she grew and grew, evolving. I added one glaze after the other and her energy permeated my space. One year later….. I finished painting "Sheer Bliss" Oil on linen 40X40".

The simple red bloom with its core open to the golden light of the spiritual energies of the universe was the first. The first attempt to capture on canvas the richness and the passionate soul of the fiery flower.

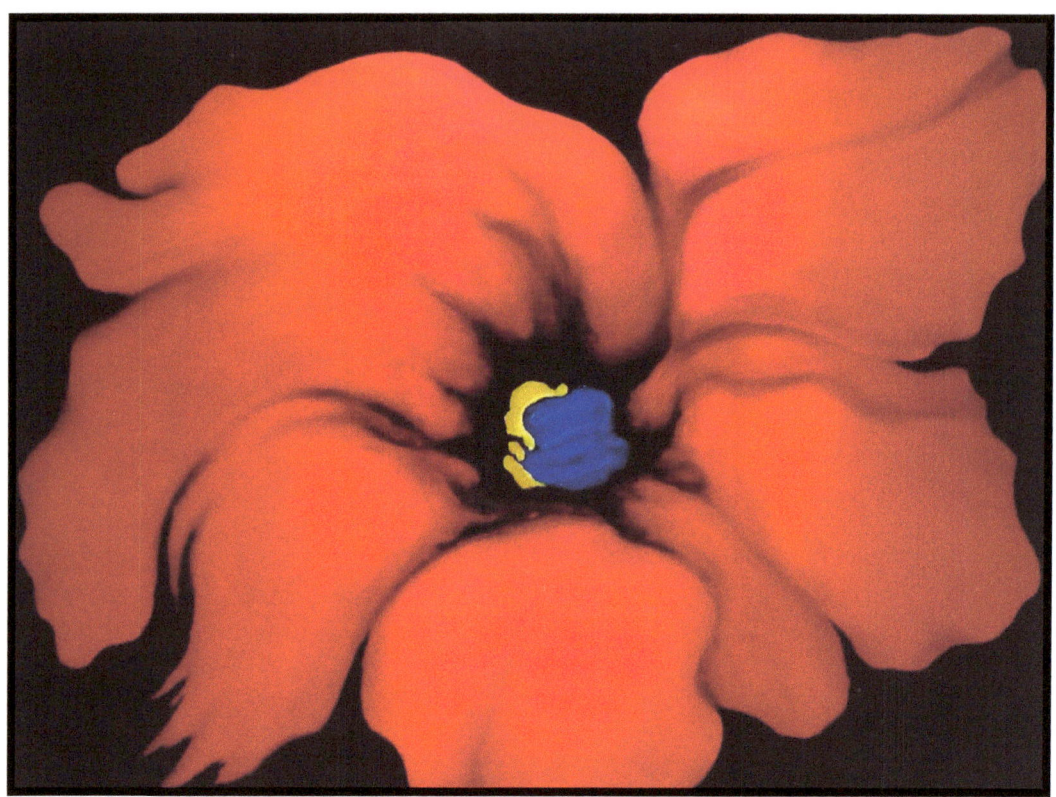

"FIRE FLOWER" Oil on canvas 30X40"

Did you ever see a masculine flower? I think not. I was seeing red! And I had the perfect large canvas, one just big enough to hold the large Crimson bloom. Red….the color of passion!

I felt the flower growing and expanding as I painted faster and faster. I had the feeling that the flower was filling the universe and giving birth to other flowering universes. As this thought took hold, the golden stamen evolved into the female form ..female…birth…creation!

The red flower… passion, the richness of the Crimson bloom!
How can a simple oil painting capture
God's masterpiece?

The colors screamed at me, I felt this energy take over as elongated forms appeared as the stamen intertwined and then a human form started emerging on the canvas…… reaching searching for truth wisdom and eternity.

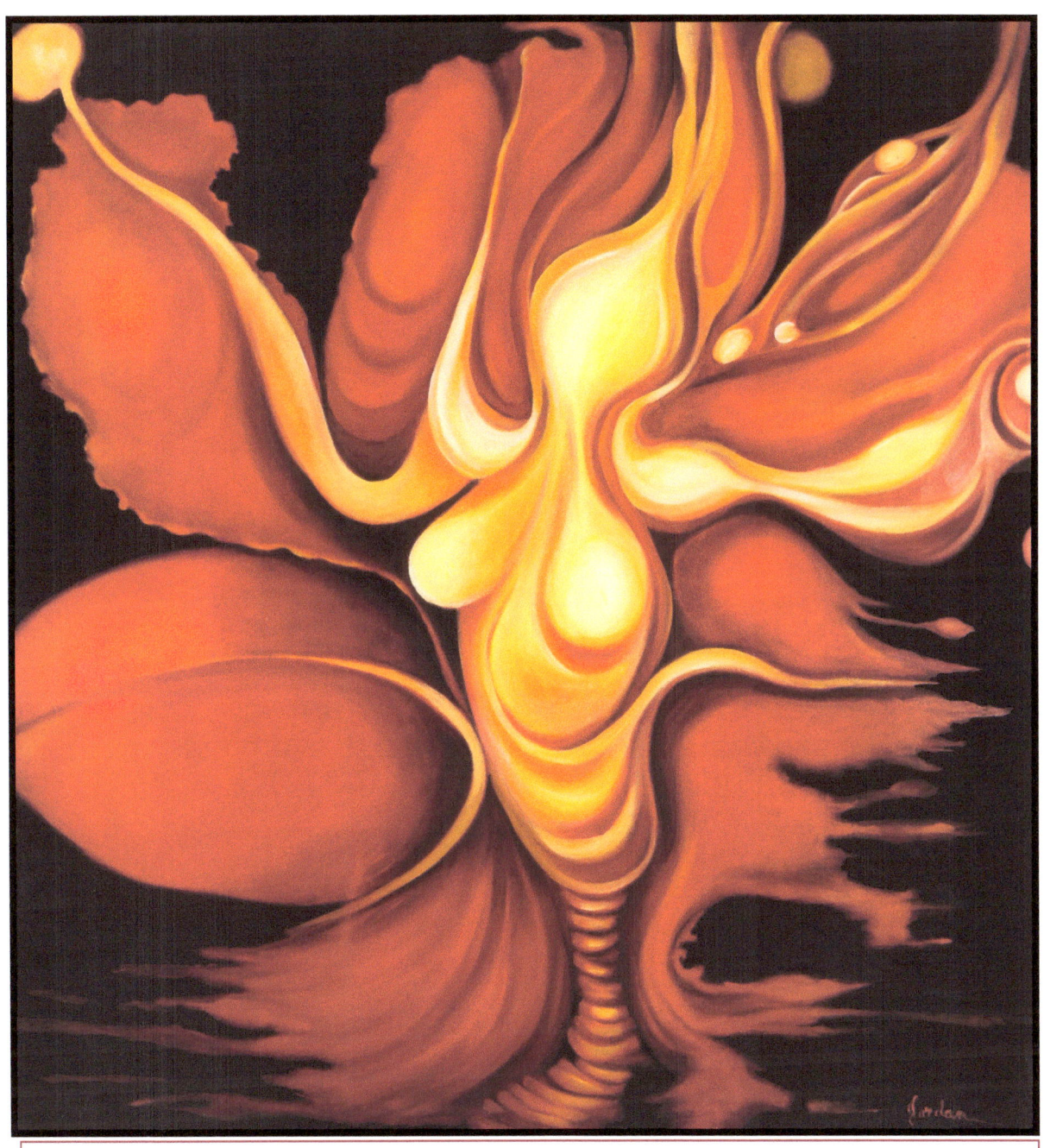

"VENUS RISING" Oil on canvas 42X42"

Stamen-Like appendages flow from the heart of a red bloom and intermingle with crystal spheres

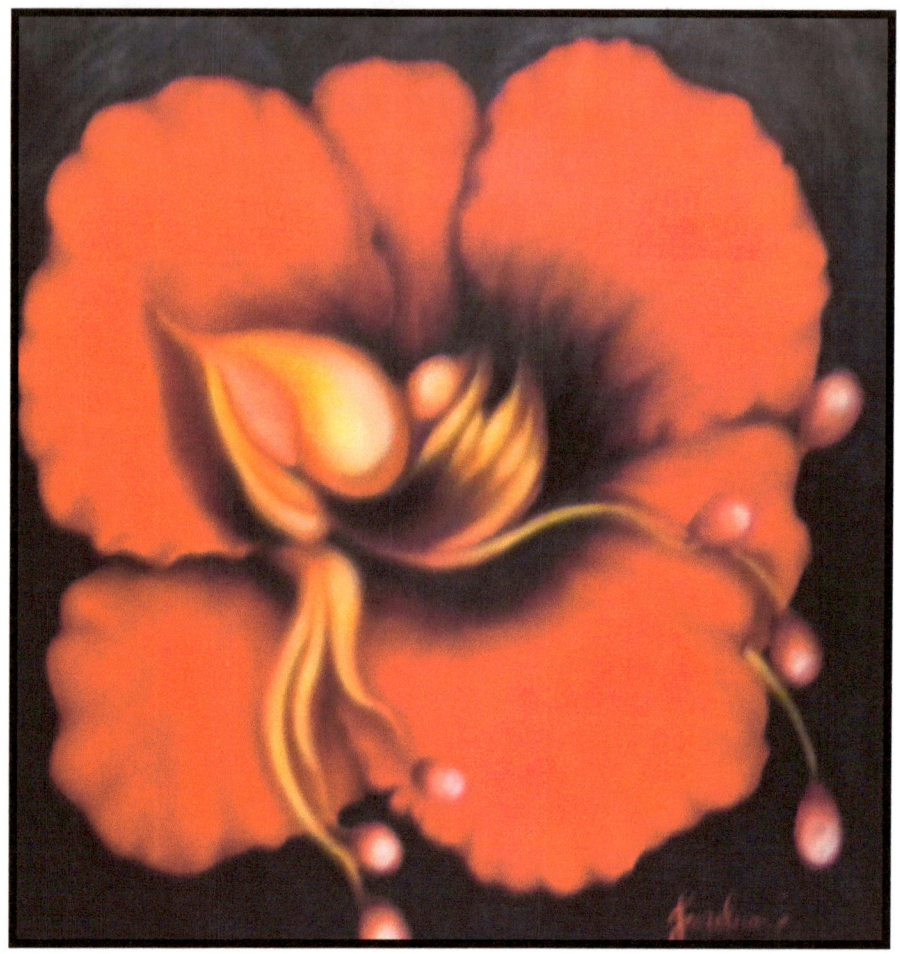

"PASSION FLOWER" Oil on Canvas 30X30"

Not feeling satisfied that I have completely explored the red bloom, I find I am compelled to become involved in exploring another red flower whose stamen seemed to be twisting and evolving into a spiraling energy form.

Where did that energy spiral originate? The golden stamen unfurled from the spiral and seemed to flow around the bloom, so I just went with the flow.

As I painted the red flowers I felt the swirling energies flowing through each and every petal. I painted the energies within the flowers…not just what the external eye could see. I felt I could actually see the warm energies flow from the flowers into the atmosphere around them.

The vase was filled and over flowing with large exuberant flowers straining to be free. What fun!

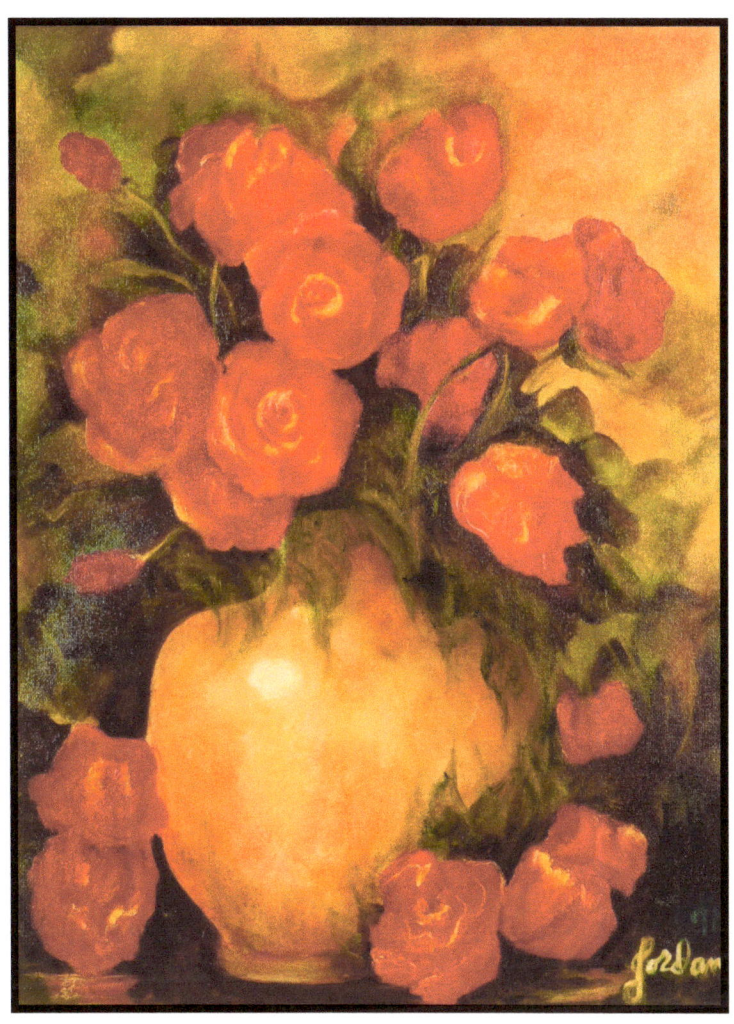

"ANTIQUE RED ROSES"
Oil on canvas 14X18"

The more I stared at the tulip, the more uniquely beautiful and other worldly it seemed...

This Tulip actually sang to me! Golden warm sunlight flowed through the tulip. As I painted, the flower kept re-creating itself....as if the male and the female...unified in it's creation.

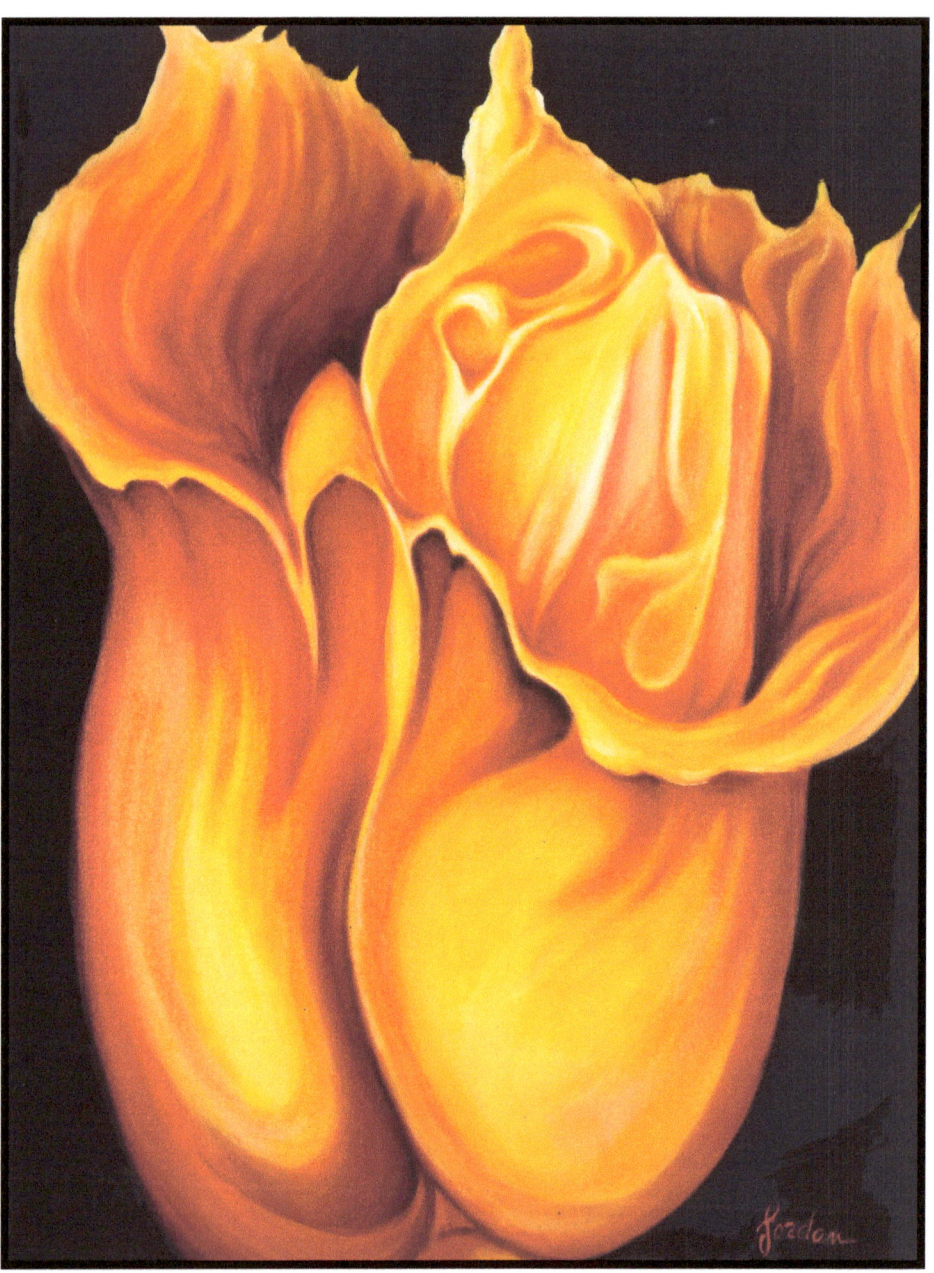

The **"SINGING TULIP"** Oil on canvas 30X36"

"UNIVERSAL ENERGIES"
Oil on canvas 30X40"

How does one capture the underlying energies of the universe with a mere brush and oils? Start with the amoeba, the intricate cell structure of the homo sapien, or a simple petal on a rose. All are created from the masters universal brush. Are the planets and all that dwell within, .on, and between, one and the same? Nothing stands still…..all are made of energy constantly moving ebbing and flowing throughout eternity changing morphing never dying……INFINITY!

Contemplating "Infinity", led to my painting the universal energy series of oils on canvas. I like to paint the energy at the source, From the inside out. In other words, the energies that dwell within. The energies unseen ….. yet felt. One could say I tried painted my psychic impression of things unseen.

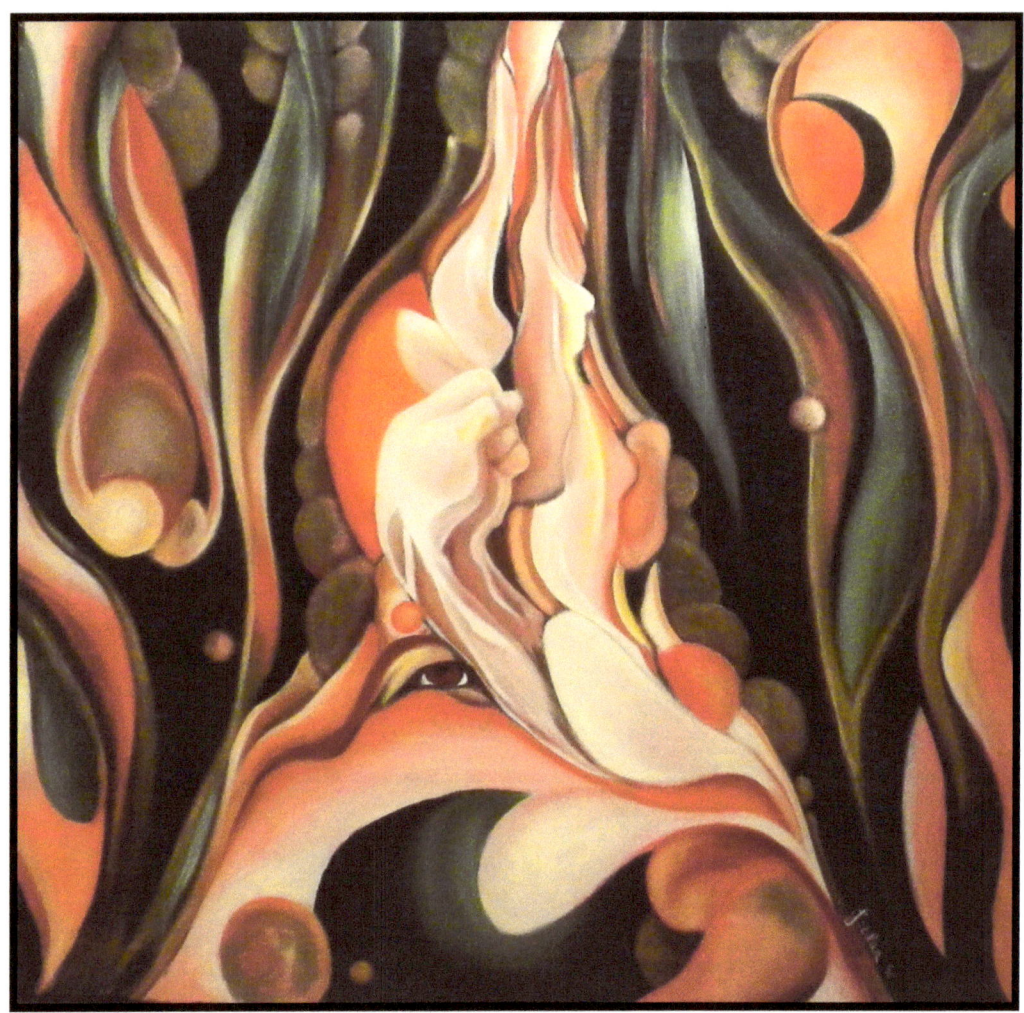

"THE POWER" 28X28" Oil on canvas

The colors screamed at me, I felt this energy take over as elongated forms appeared and intertwined and then human forms started emerging on the canvas……I simply let the energy flow through me and the brush. True power!..The power of wisdom!

I try to tap into the universal Wisdom . The wisdom that lives in the eternal light.

Then comes the birth of my visionary impressions of what I call the human condition. I felt their emotions, their struggles, longings, desires, hopes and dreams as they strive for love, for expression, and for understanding. I let the feelings flow though the brush onto the canvas. I felt them evolve and grow as I painted. I just went along for the ride.

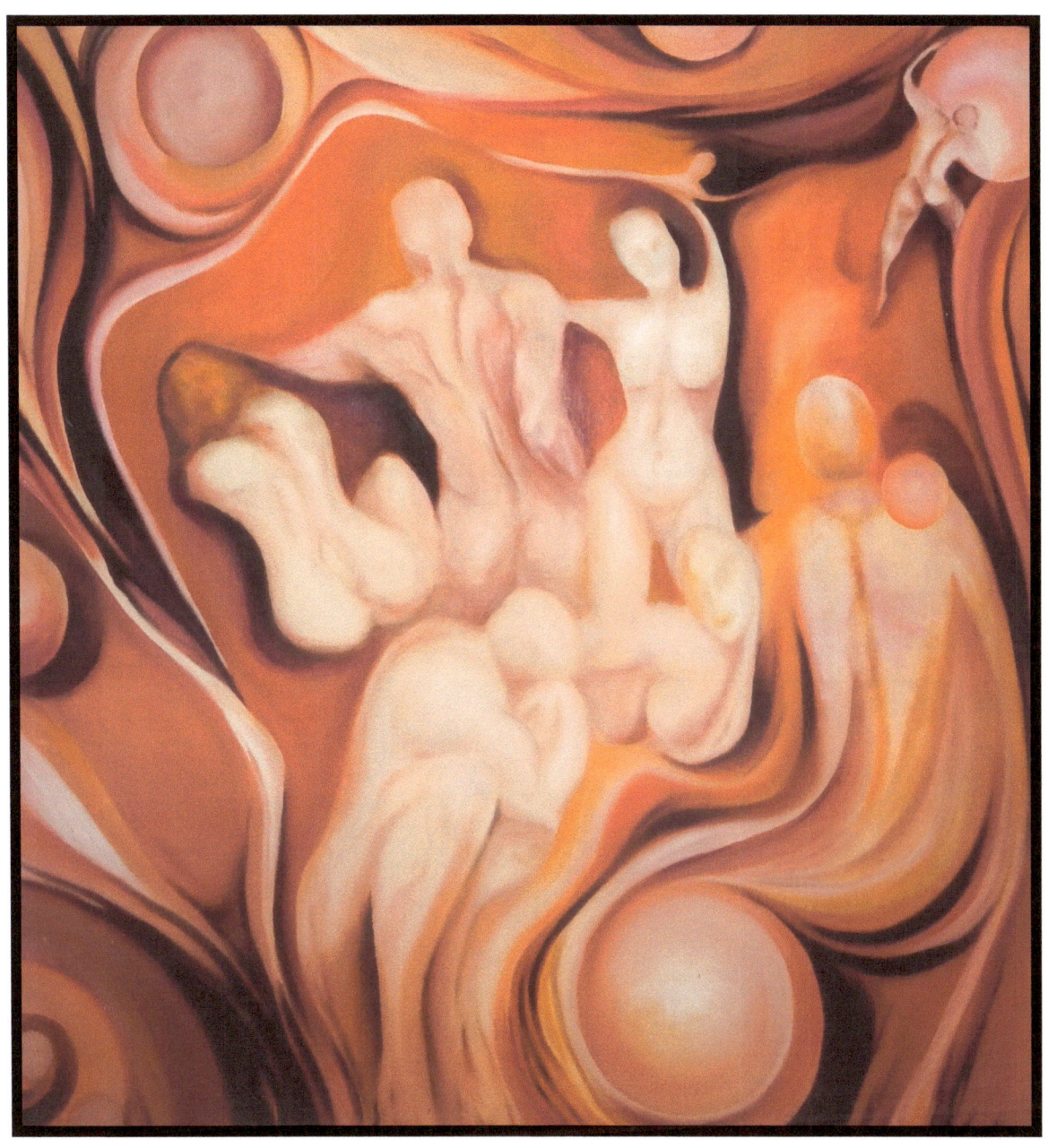

" HUMAN CONDITIONS"
Oil on canvas 44X44"

. The Northern Lights in all its glory. I imagine them as the planet celebrating— having a party.
"PARTY TIME" Oil on canvas 24X28"

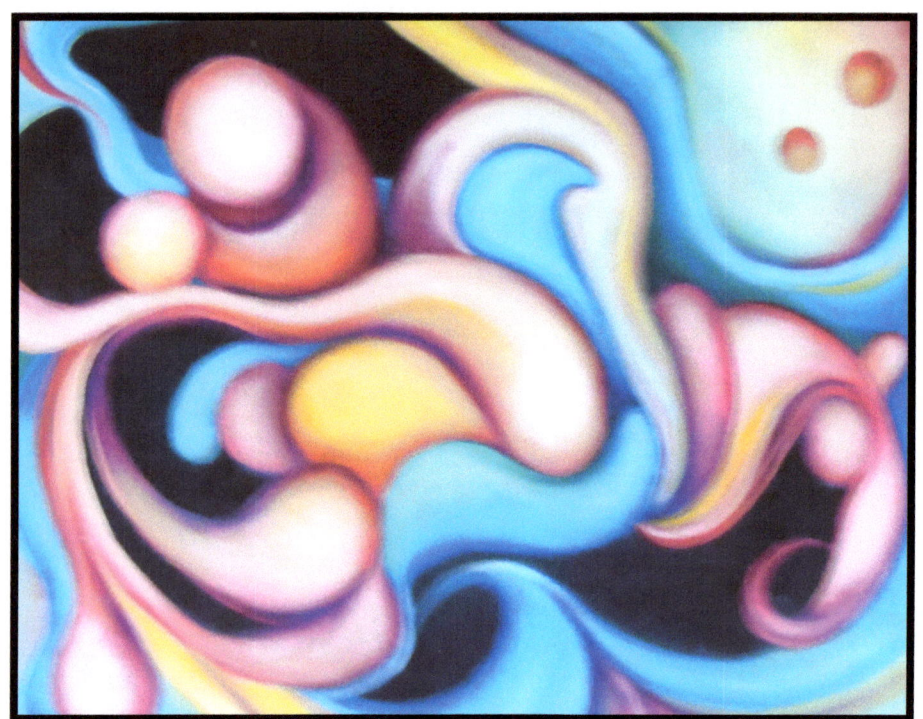

Love those flowers
"BUTTER FLOWER"
Oil on canvas 22X28"

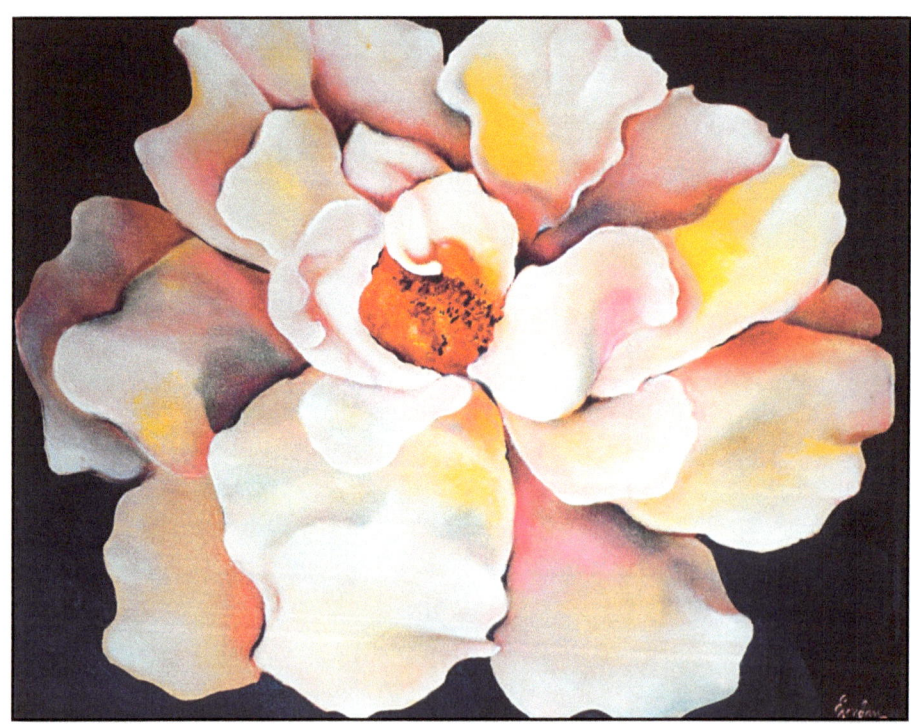

What a joy to sit next to a brook and listen to it's music and to see the constantly changing colors and swirls as the water ebbs and flows around the rocks

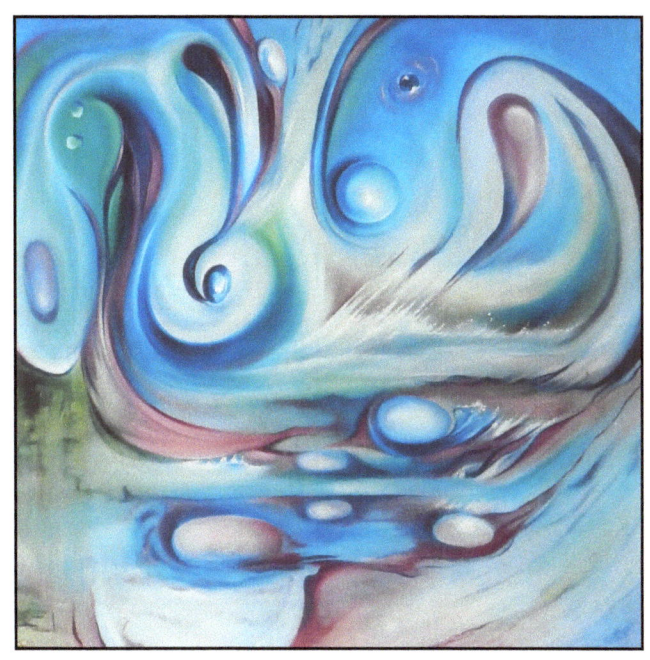

"THE BROOK"
Oil on canvas 24X24"

I wonder about universal wisdom. Is there a universal eye watching over the uni-

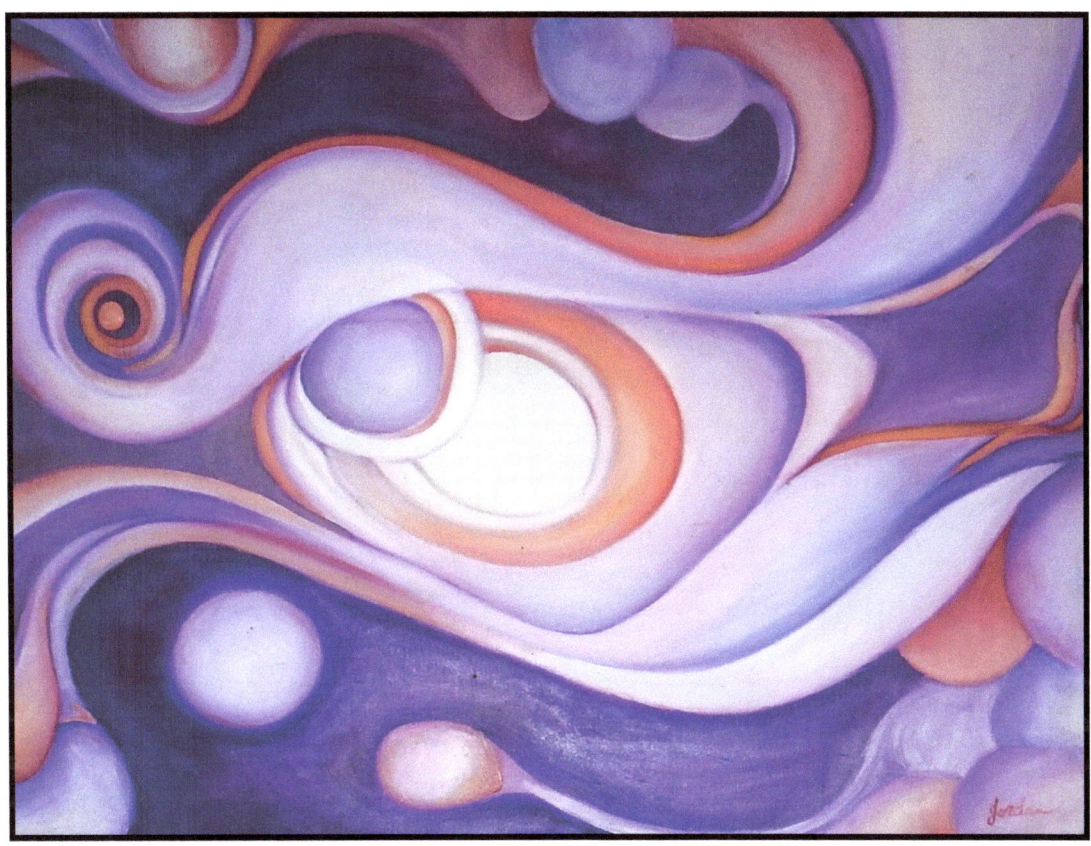

"EYE ON" 30X40" Oil on canvas

To capture the true essence of your subject you must fall in love with the subject

What is love? The beginning of all that is……all that exists perhaps. Thus I painted my intuitive expression of LOVE.

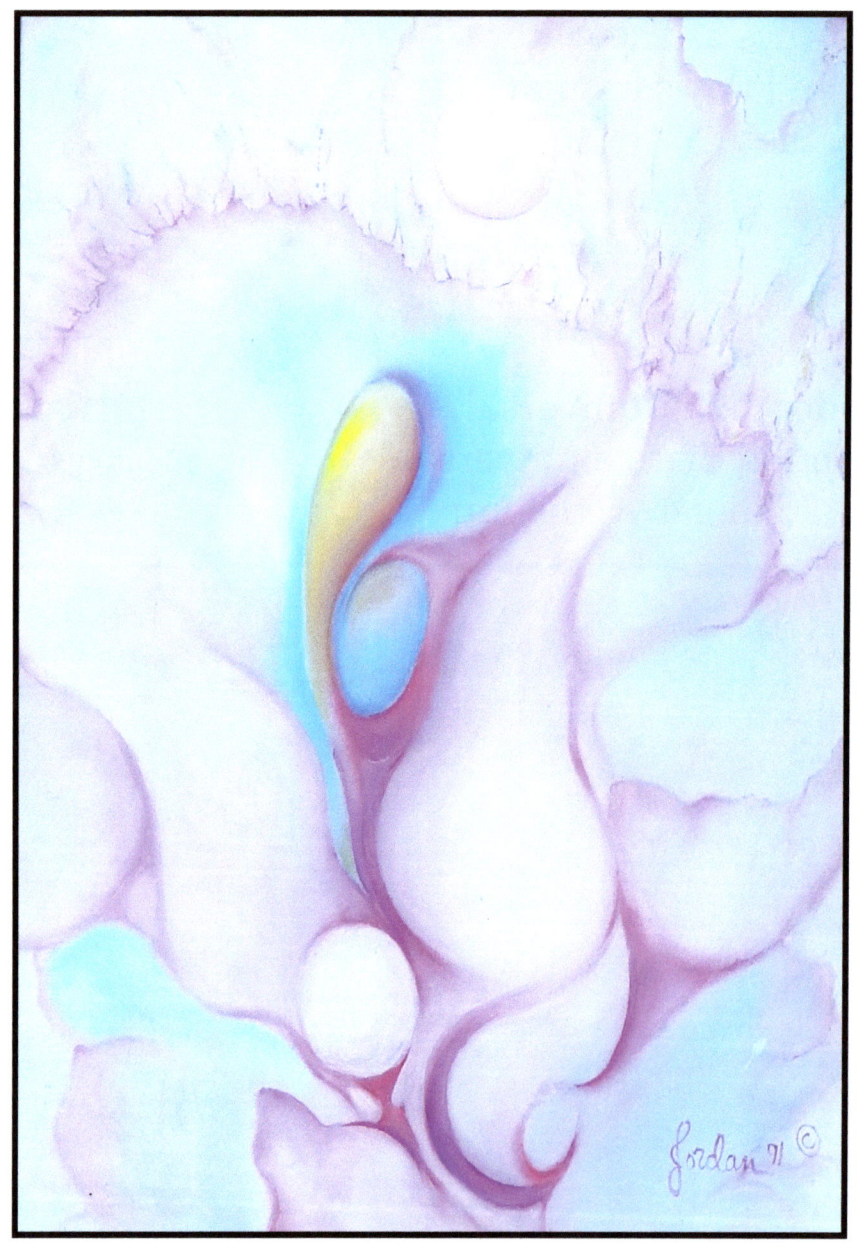

"LOVE"
Oil on canvas 18X24"

Music, the universal language and some say the language of the universe..."math"
Here I paint music as it warms and enlighten our world and the worlds around us.

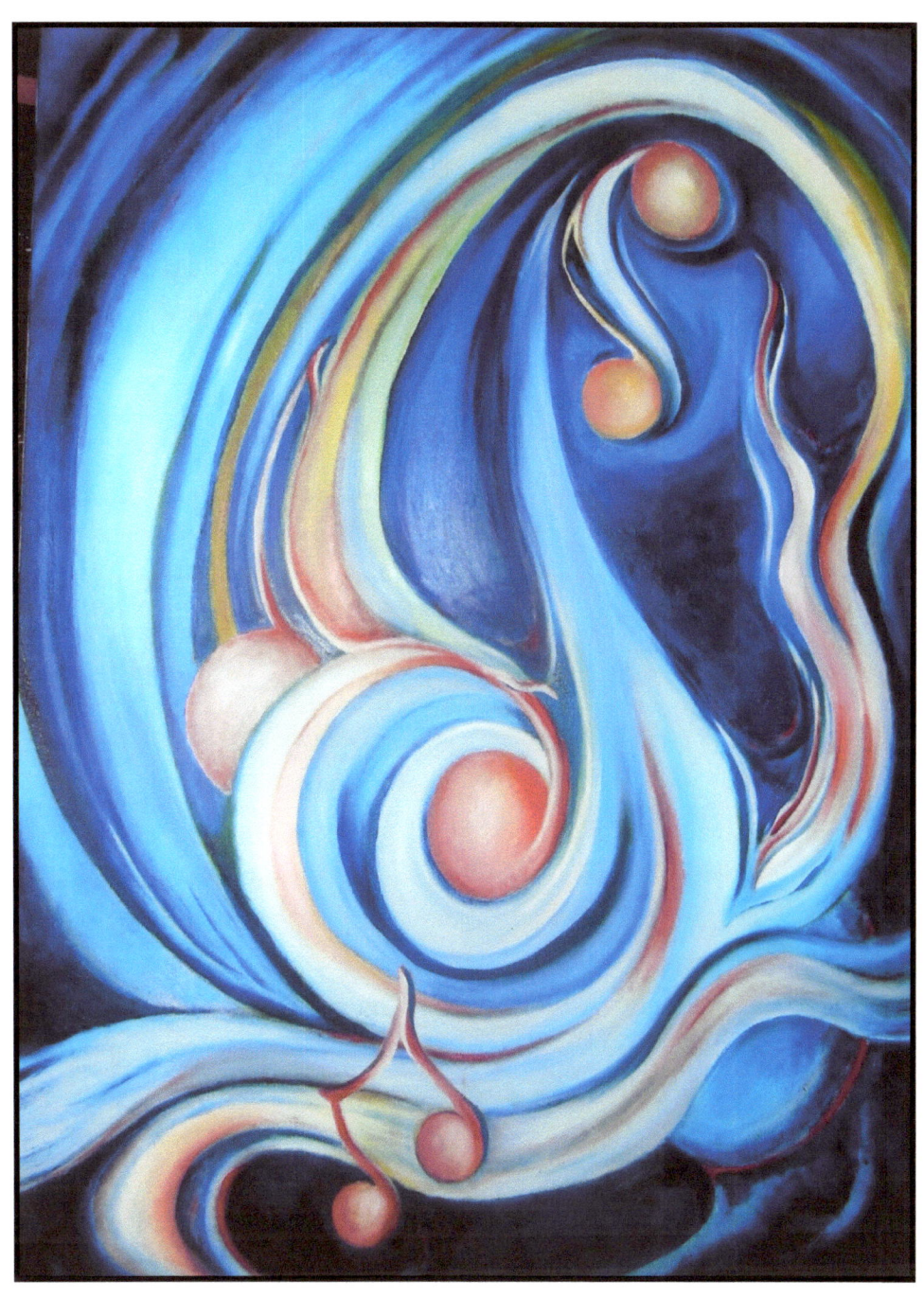

"MUSIC OF THE SPHERES"
Oil on canvas 30X40"

"BALLS" Oil on canvas 18X24"

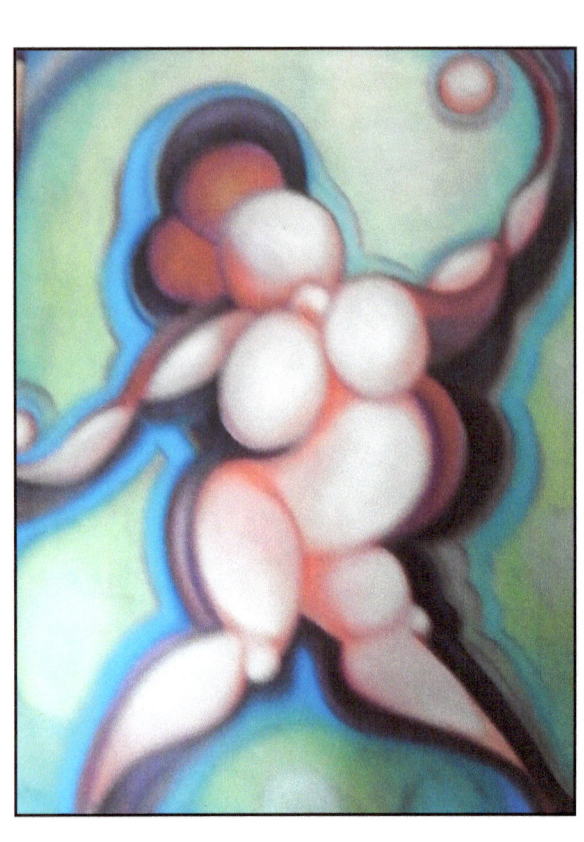

Lots of bananas turn into arms, legs, boobs, big boobs! Moving flowing joyful! Dancing! A celebration of life!

"BOWL OF FRUIT" oil on canvas 32X32"

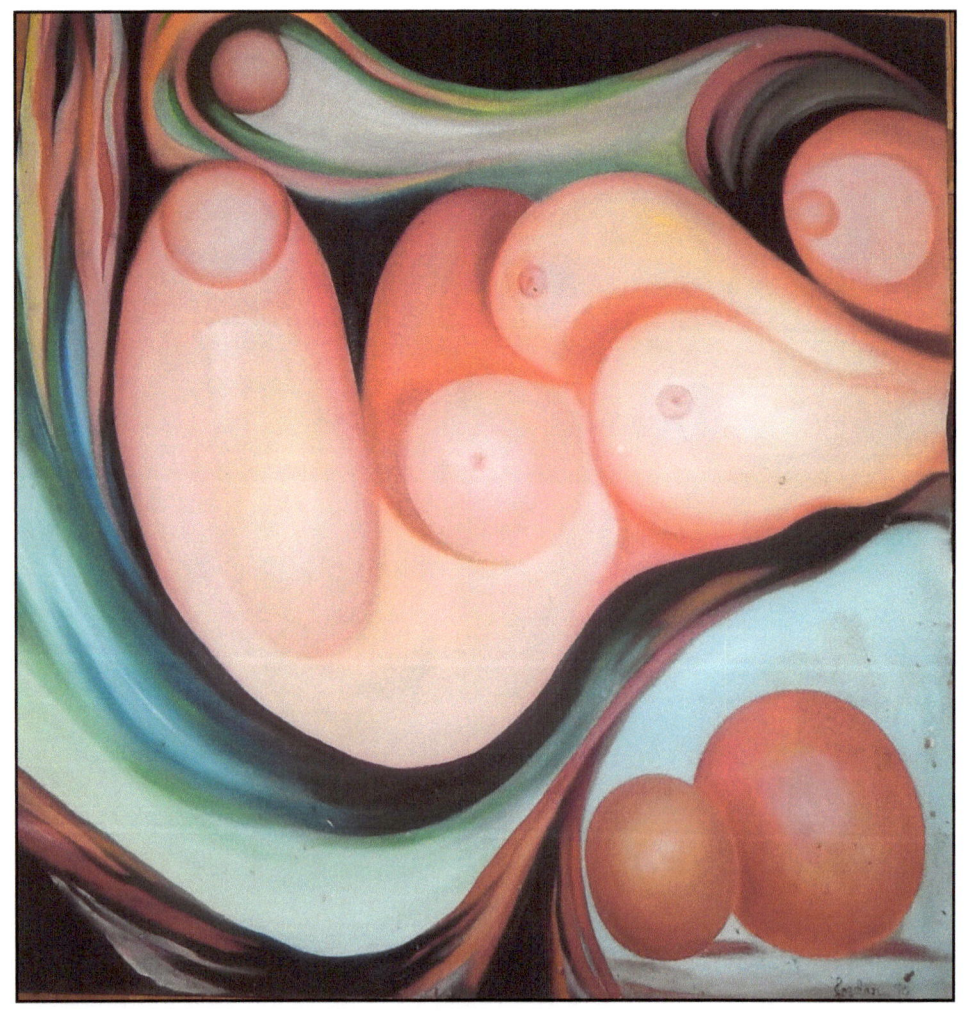

"I stared at the bowl of fruit for quite a while as it seemed to morph into a bowl of female body parts. Parts that kept moving and dance in the sunlight. My brush couldn't help but paint what my mind was seeing, The more I stared at the bananas, apples and pears, the more I saw human forms. As I painted, the energy within that bowl of fruit flowed through my brush.. Melons, oranges, pears apples, a cantaloupe & bananas. Lots of bananas.

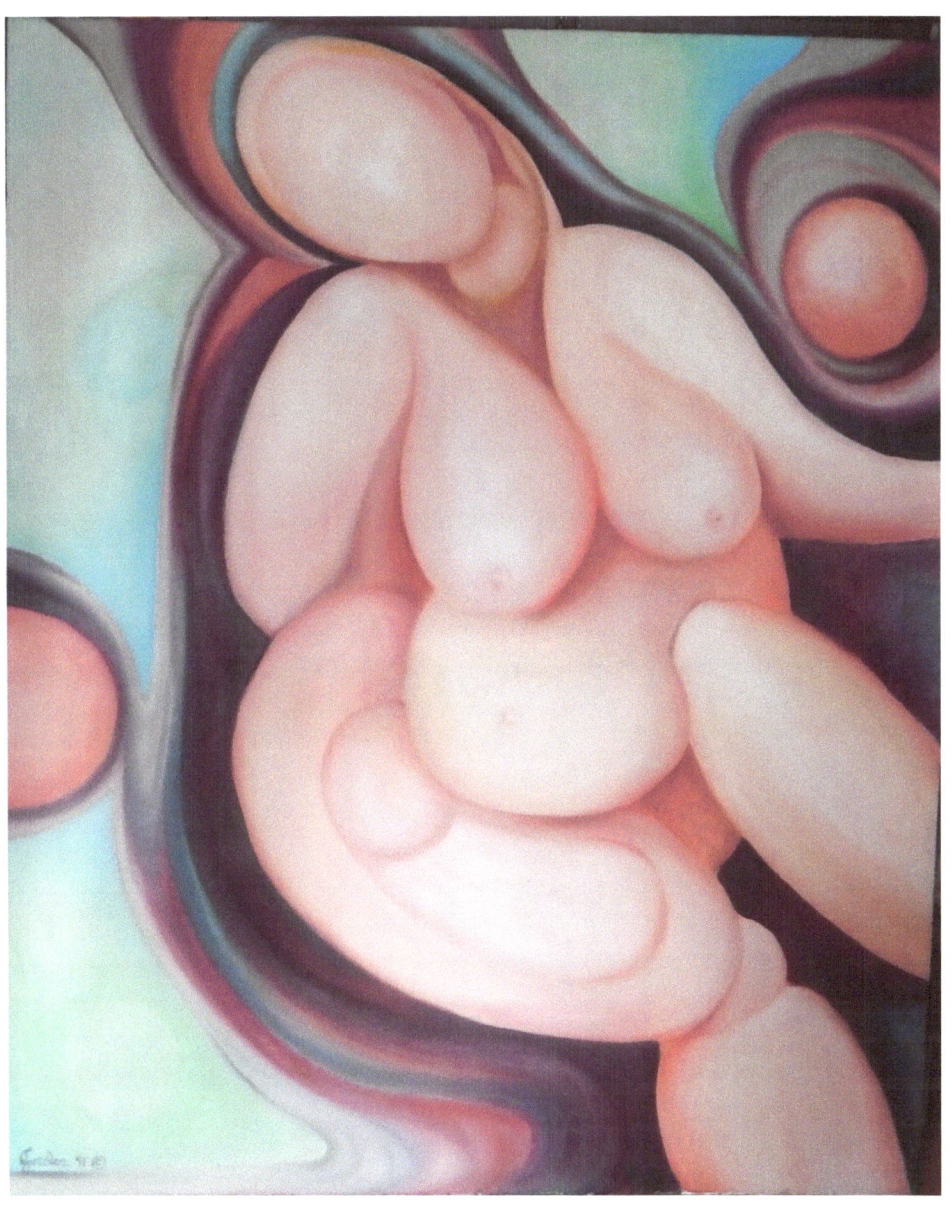

"RUBENESQUE"
Oil on canvas 42X52"

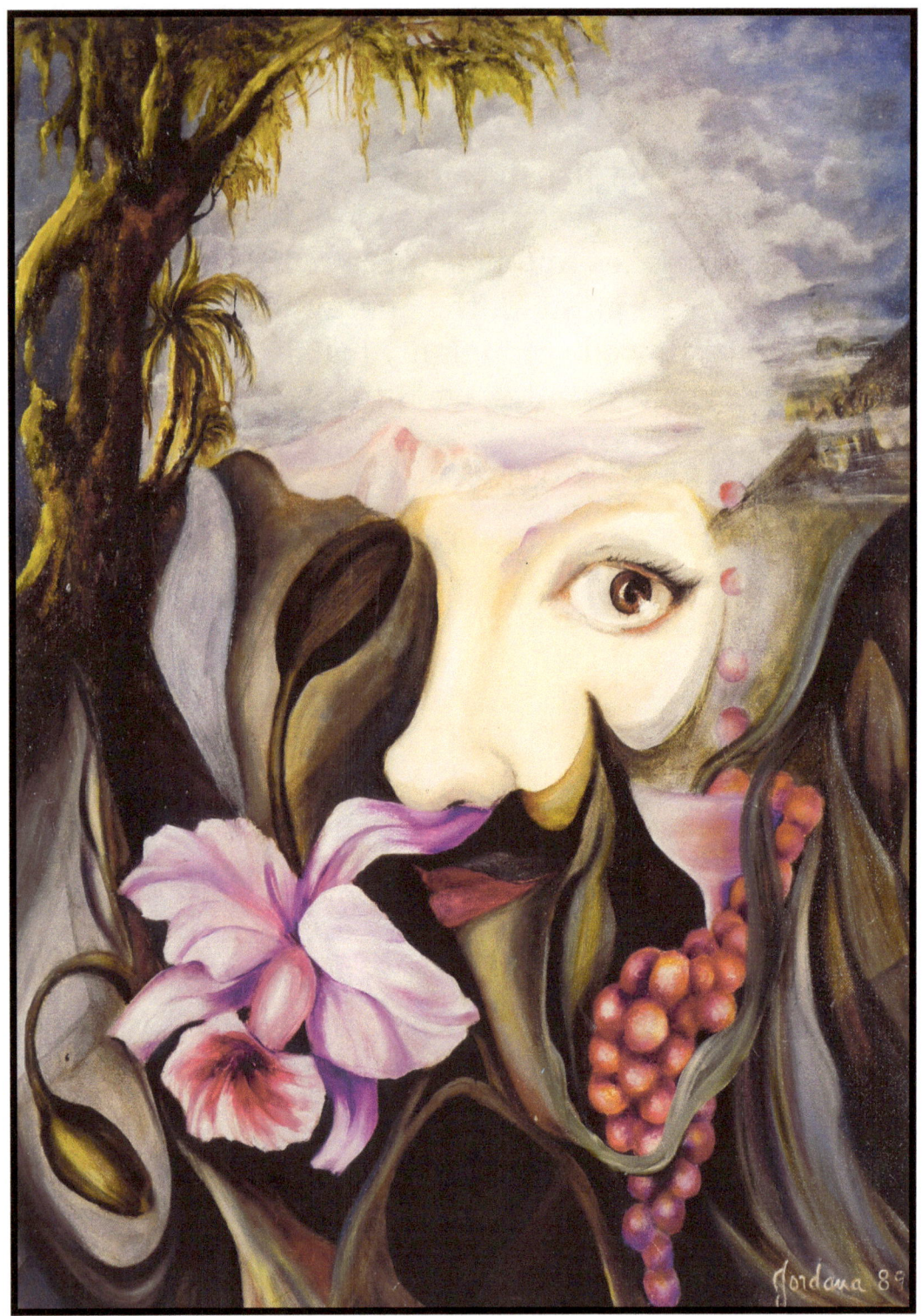

"MOTHER EARTH" Oil on canvas 20X24"
There are times when I begin painting a landscape only to wind up with life forms show up in the middle of a tree or the sky or the ground. Now how did that happen???
For instance, my Mother Earth painting.
I love painting from nature. What I see may be slightly different than what someone standing next to me will see.

Many times when I am painting, I am unaware of what I am painting, I only know that I am painting. I am often shocked when I see the finished product.

A dealer once suggested I might have been taken over by a spirit from the other side. Well, maybe…….

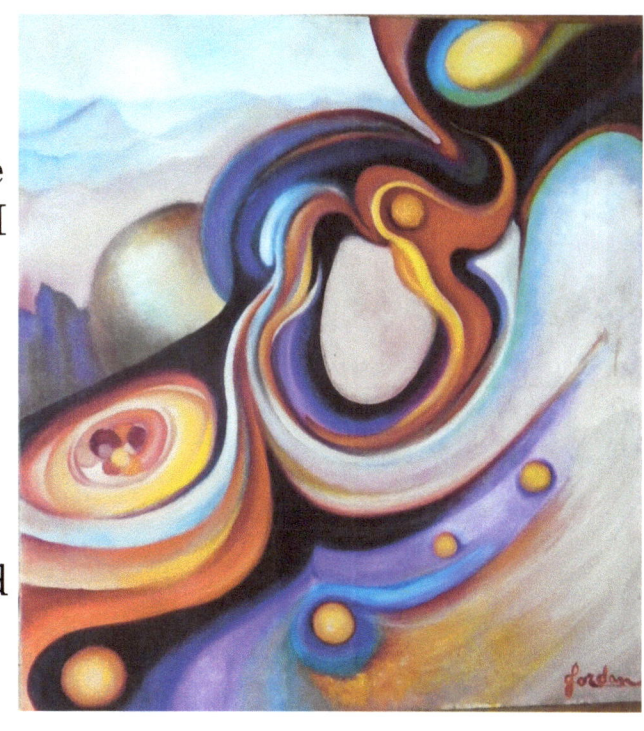

"THE ANGEL" Oil on canvas 24X28"

I realize I have a lot of orbs in my paintings. I love orbs. All orbs! Those from this dimension or any other.

Circles have no beginning and no end.

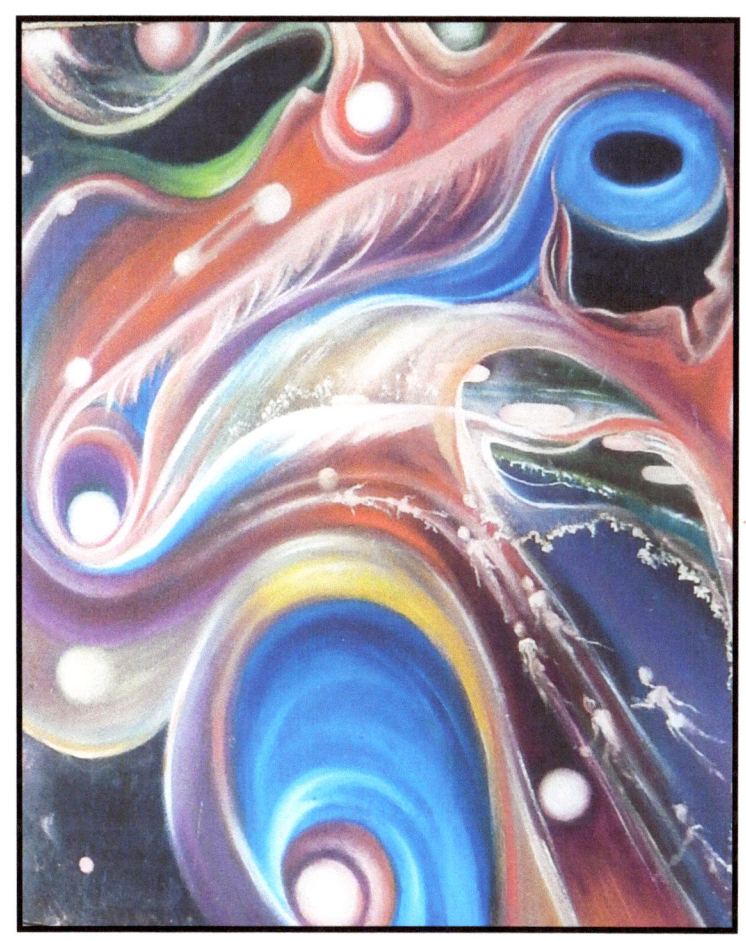

"GALACTIC TRAVEL"
Oil on canvas 18X24"

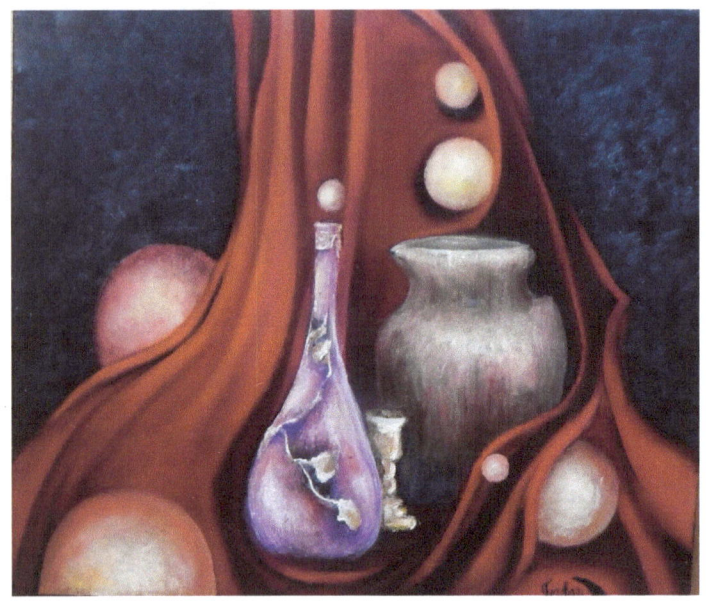

I started painting a nice still life……then it changed. I swear I saw orbs floating around the area…so I added them …. Why not? I think they add a lot of charm.

"THE STILL LIFE"
Oil on canvas 20X24"

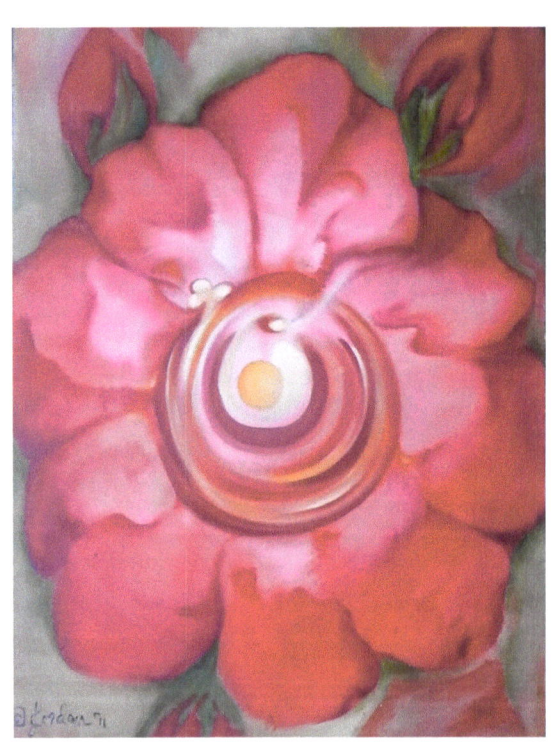

Sometimes we have to demolish in order to correct …. create.

One must break eggs to make an omelet.

"BIRTH"
Oil on canvas 18X24"

I have tried so hard to remember my dreams. Night after night I promised myself I would remember them and paint them. Finally I remembered. Well, this is the result. Try explaining this one to a psychologist. I swear I traveled to a different dimension.

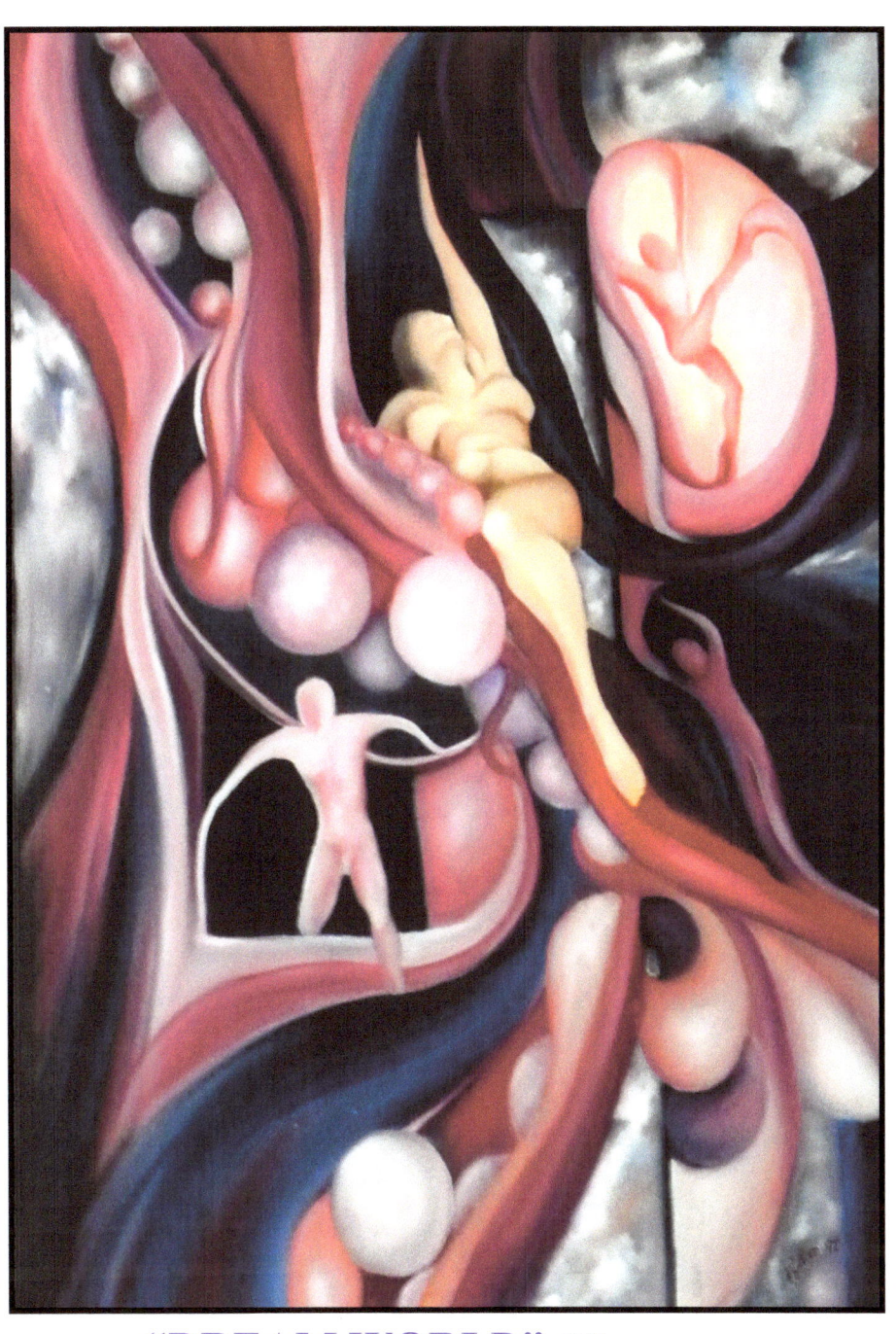

"DREAM WORLD" Oil on canvas 30X40"

I have had numerous commissions to paint a portrait, some in pastels, some in oils. Painting from life is very different than painting from just photographs. Usually one paints a person's portrait from both. Having worked many years as a psychic, I consider myself a student of human nature. This can sometimes work against me when I paint a typical portrait. The client wants a portrait of how they see the subject, not how I see them. Fortunately, being a student of human nature and having a very active 6th sense, I was able to fulfill their expectations.

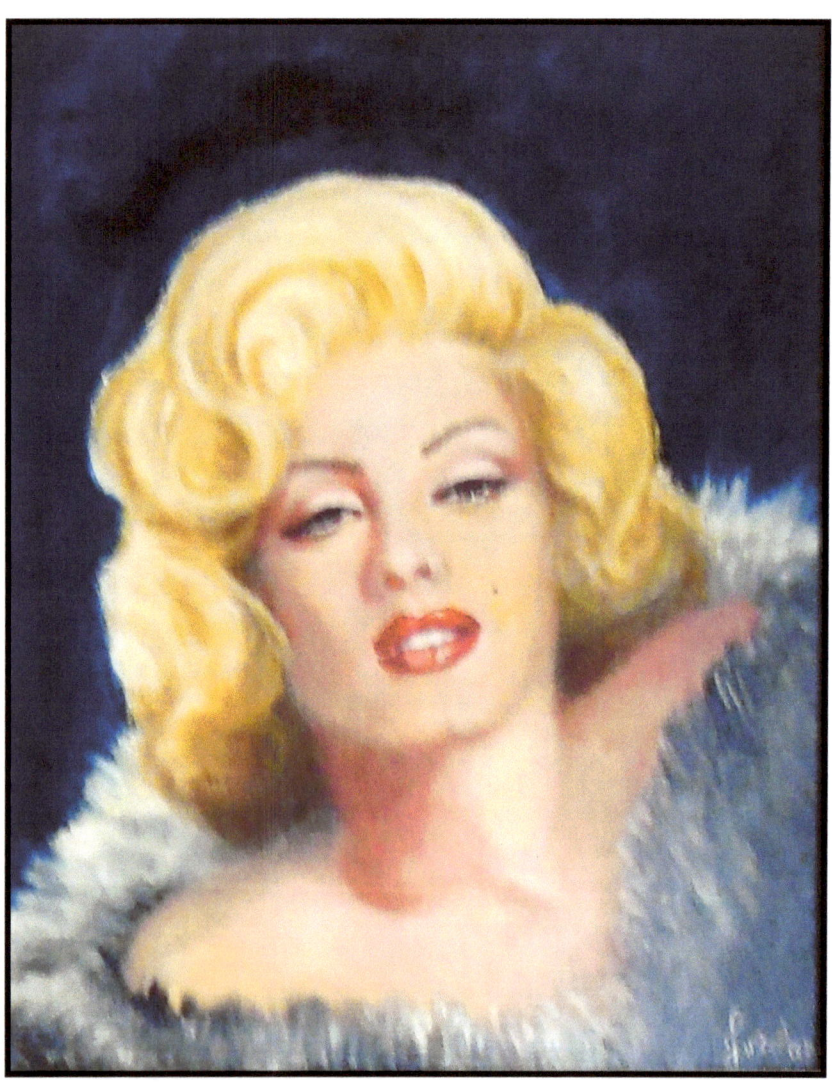

"MARILYN" Oil on canvas
16X20"

People have asked me to explain what I mean by a "psychic portrait".

I have decided to include a few of well known subjects. Hopefully the paintings will be self explanatory. The first is one I painted of Michael. This is how I saw Michael Jackson.

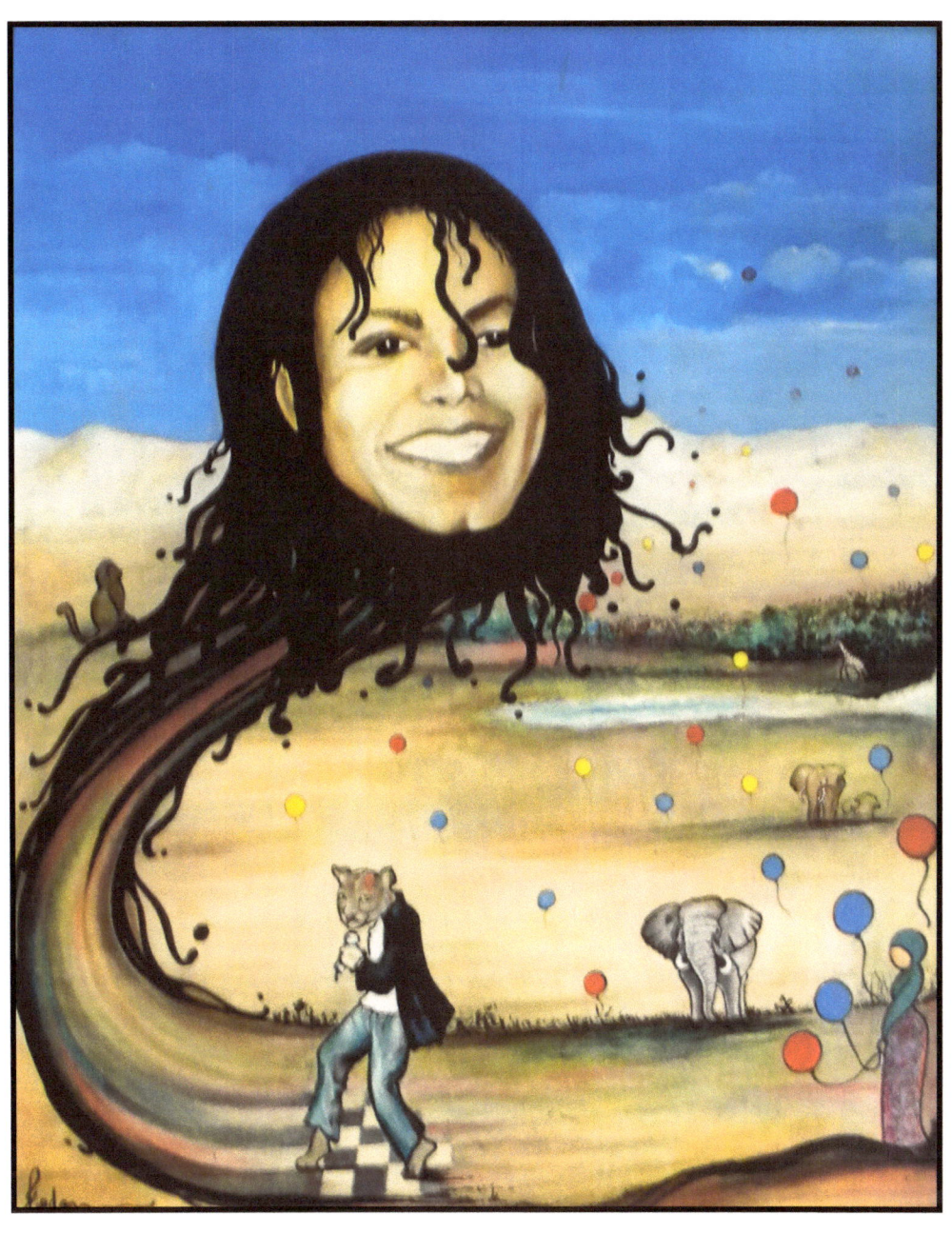

"MICHAEL'S WORLD"
Acrylic on canvas 24X28"

"NEW ORLEANS VISIONARY"
Oil on linen 24X28"

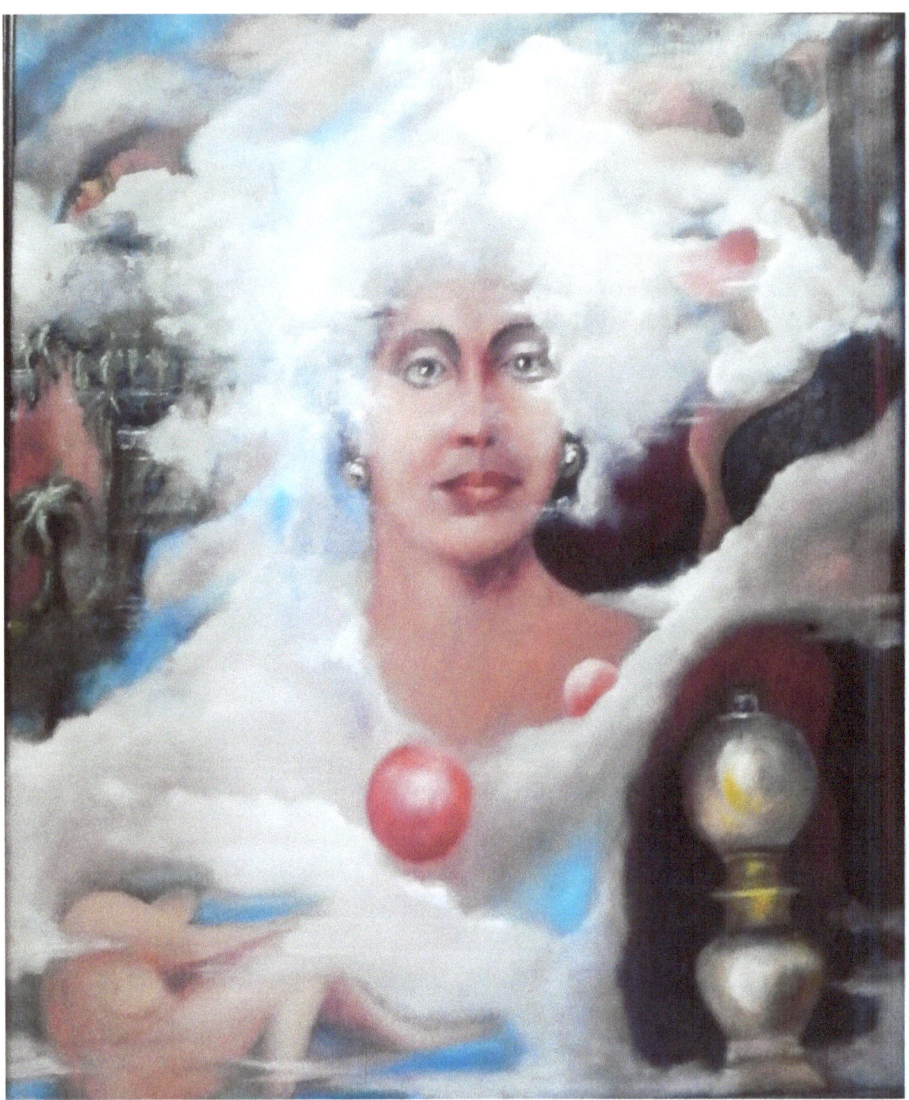

I have always been fascinated by the history of New Orleans. It is a very spiritual city with a long history of a having an interest and a closeness with the other side. Today, I am told they still live with their fascinating and perplexing old world beliefs. Superstitions? Perhaps. Perhaps not.

"THE WORLD OF WOLFE"
Oil on canvas "24X30"

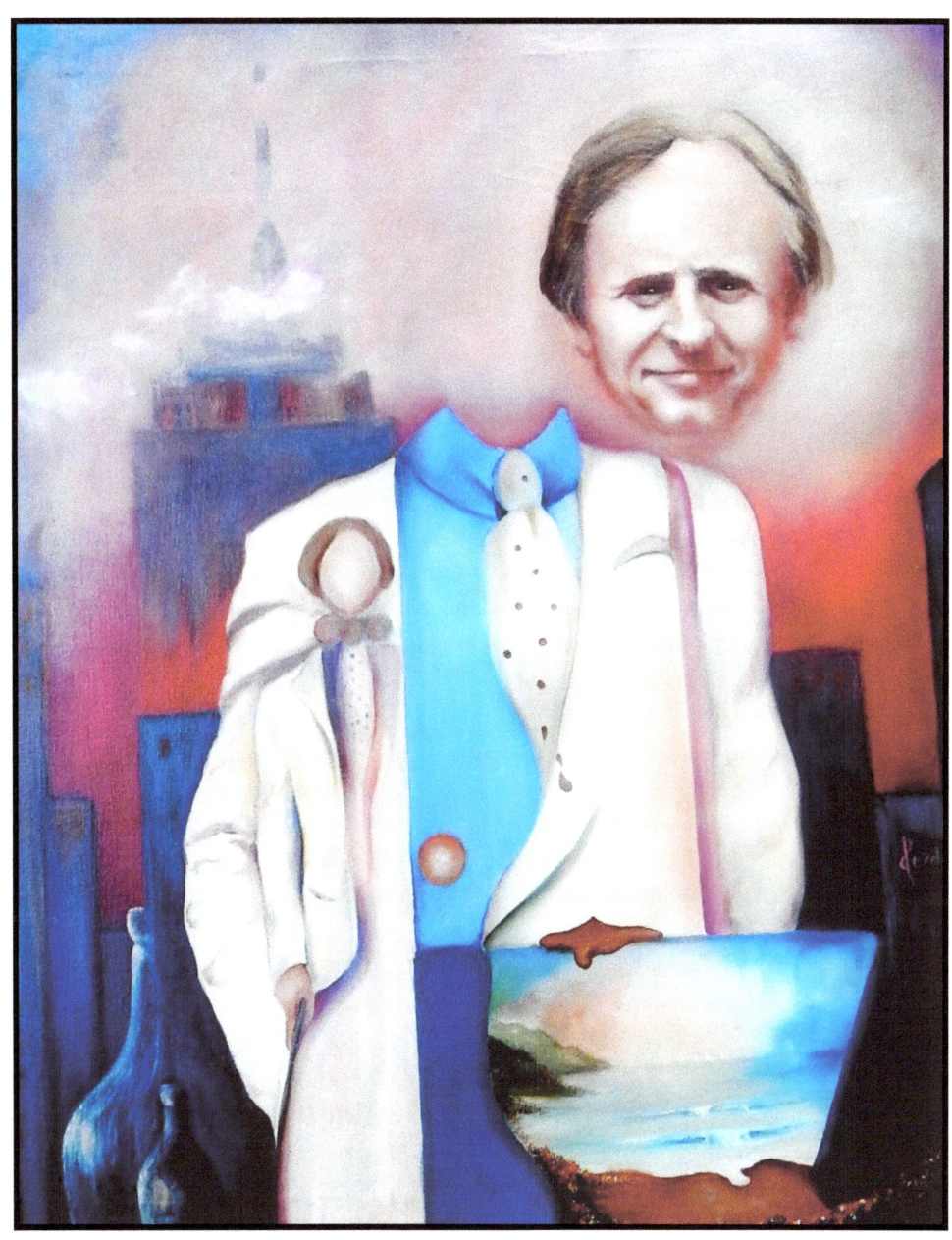

I had the good fortune to meet and converse with the fabulous Internationally known writer Tom Wolfe. The best way I can sum up those conversations is with my impression on canvas. I painted Tom, as a god creating himself over and over again in his own image. He is truly an fascinating personality.

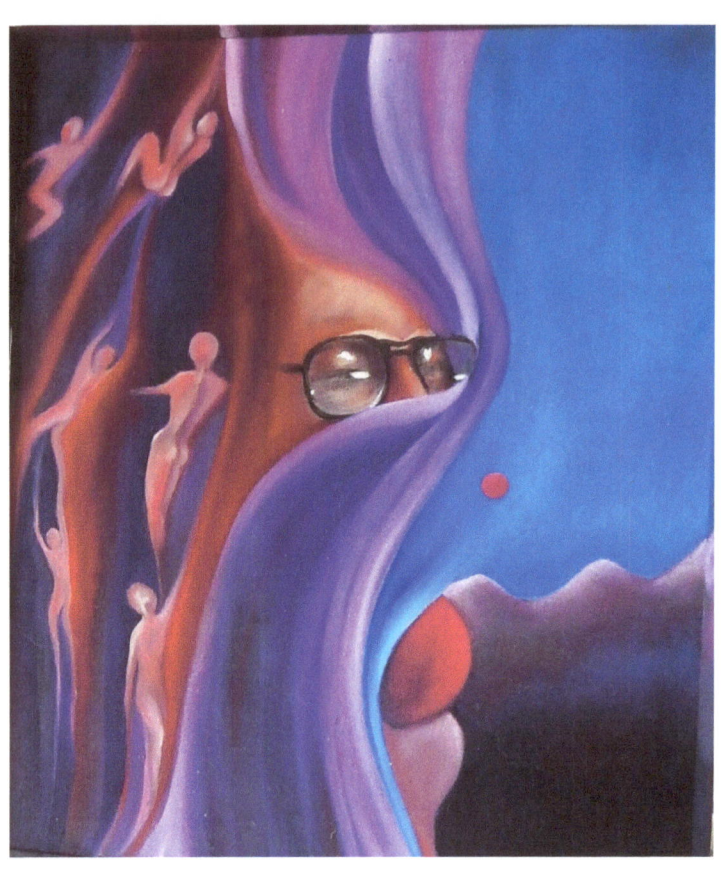

I think this dude likes what he sees!!!

"THE SEE-ER"
Oil on canvas 20X24"

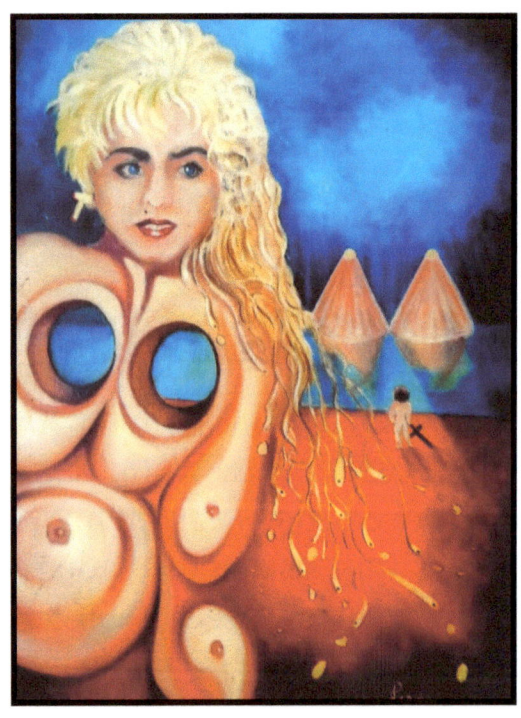

"MAD-DONNA" Oil on canvas 22X28

" This is my impression of a moment in time in the creative life of Madonna. This painting was in a one woman show I had in Greenwich Village in the 90's. Madonna saw the painting and did not like it at all. But a publisher in Great Britain did... and now it is in a book called ""Madonna In Art" . Madonna has successfully created herself over and over and over again. Hats off to her!

This painting actually painted itself. I was thinking about Inter-galactic travel and wondering how many worlds inhabit the same space in our universe. Here I think I painted a sentinel at one of the gates, Sad. A tear appears as she observes……what?…...whom? I wonder. What does she see? I wonder..?????????

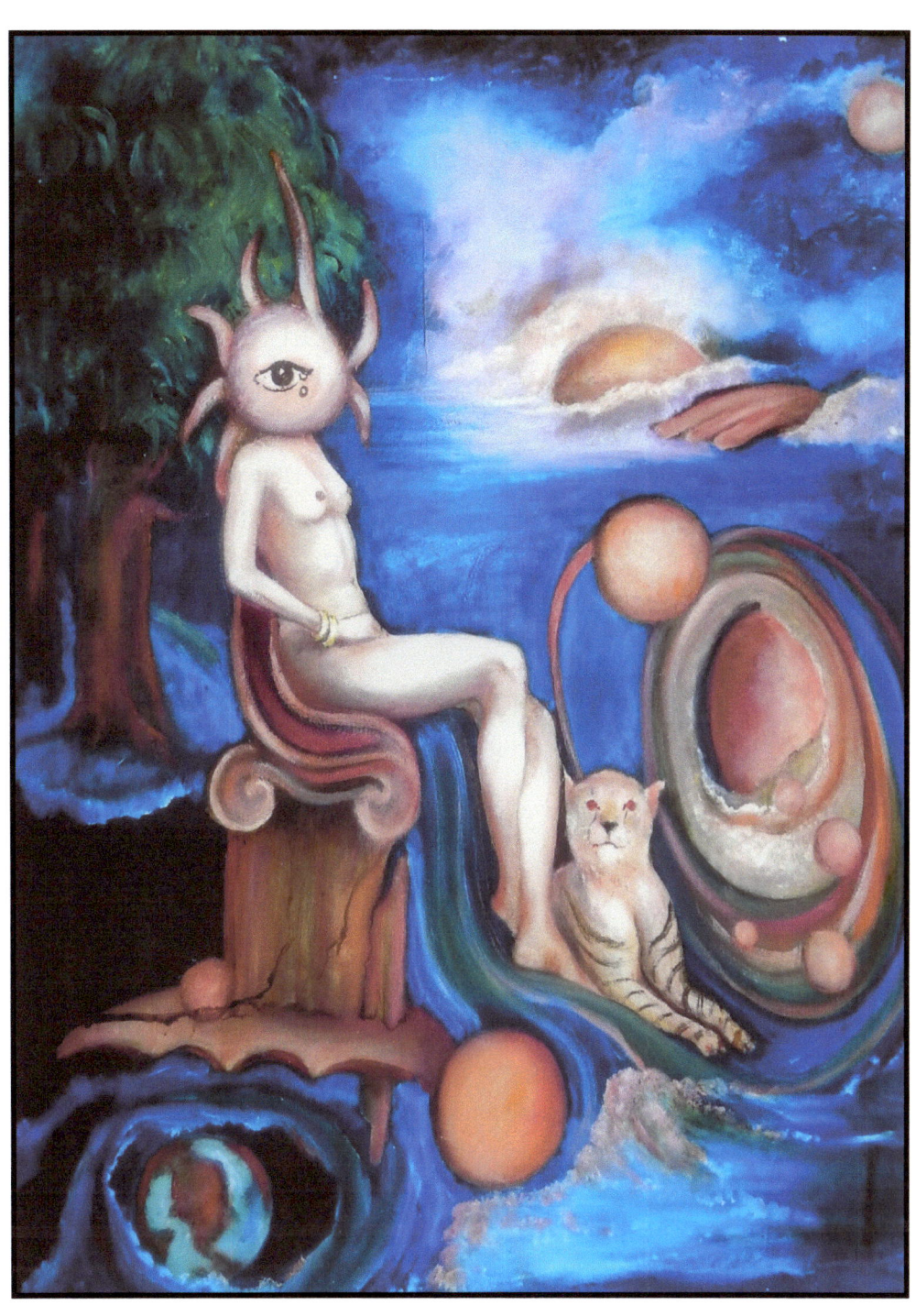

"A GODDESS AT THE GATE"
Oil nn canvas 22X28"

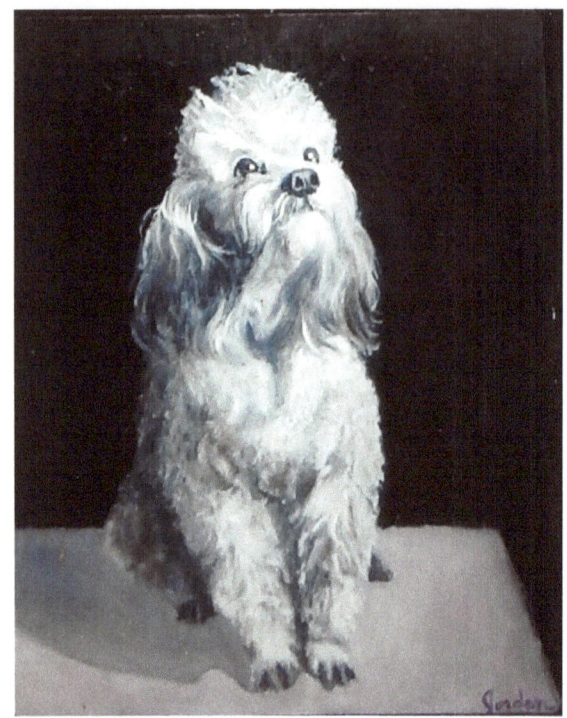
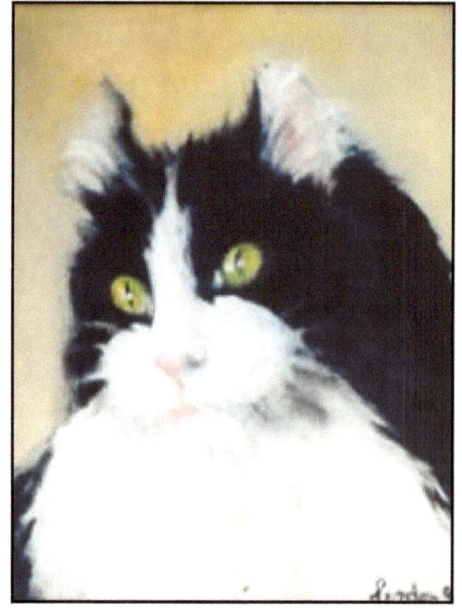
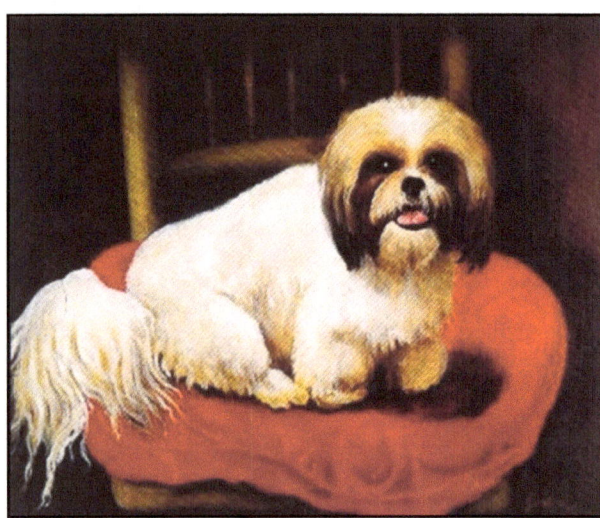

To me, painting the portrait of an animal is very enjoyable. The problem is to get them to hold still long enough to get a photograph. Many photographs.

Then the fun begins, I search the photos for the one that shows the individual animal's personality .

Each animal so unique! One brush stroke correctly placed can uncover the animals personality…..or wrongly placed can just as easily lose it. So we start all over again.

"A MAN AND HIS DOG"

A life size com-mion perhaps?

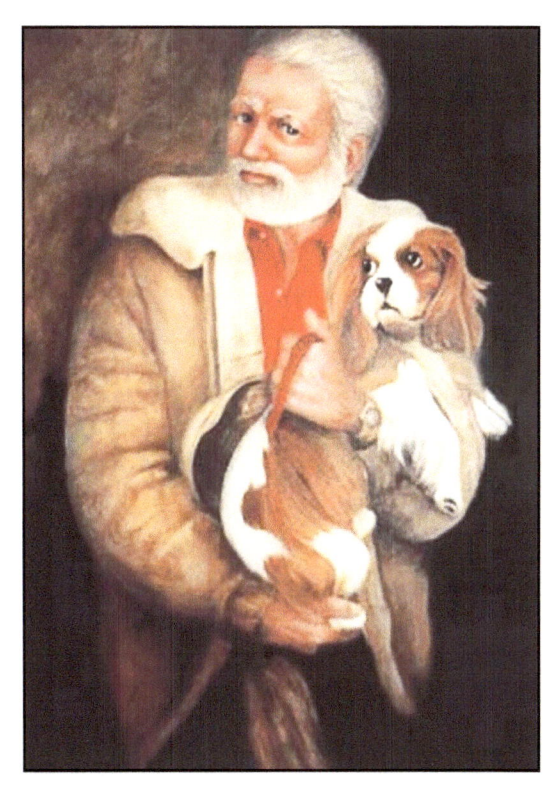

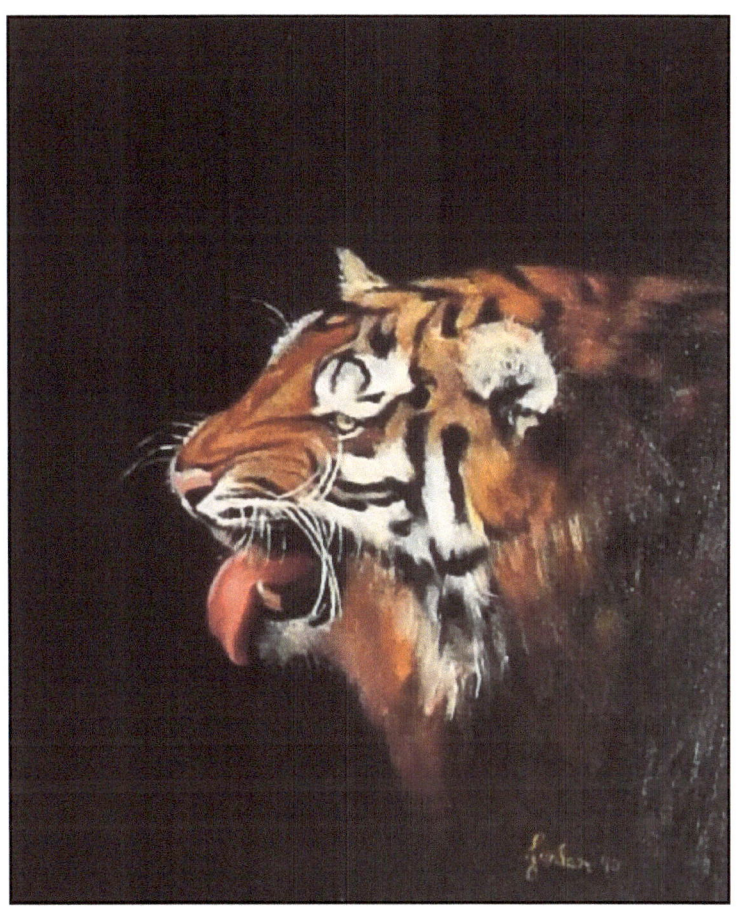

"THE SMILING TIGER" Oil on canvas 24X28"

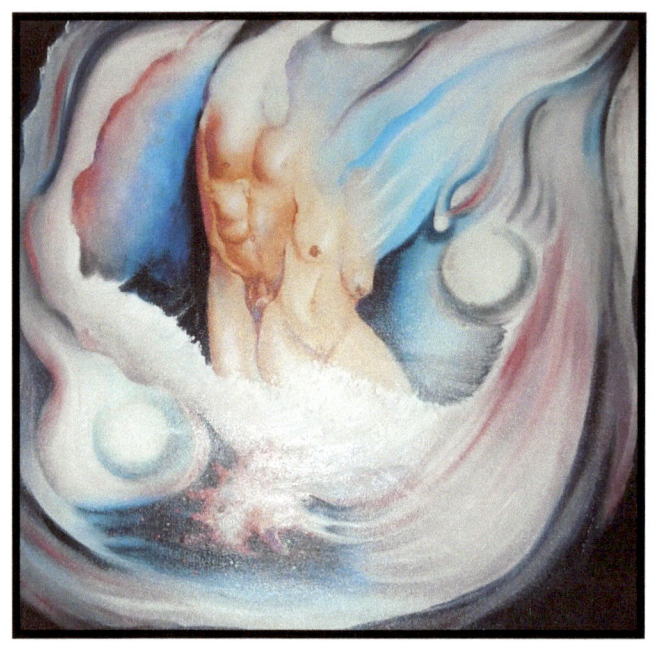

"ADAM AND EVE"
Oil on canvas 20X24"

There are usually 300 or more paintings at any one time in the studio. My web site shows part of the collection. This book is actually a tip of the iceberg.

I accept commissions and have painted a wide variety of subjects.

From simple abstracts to portraits landscapes on to murals.

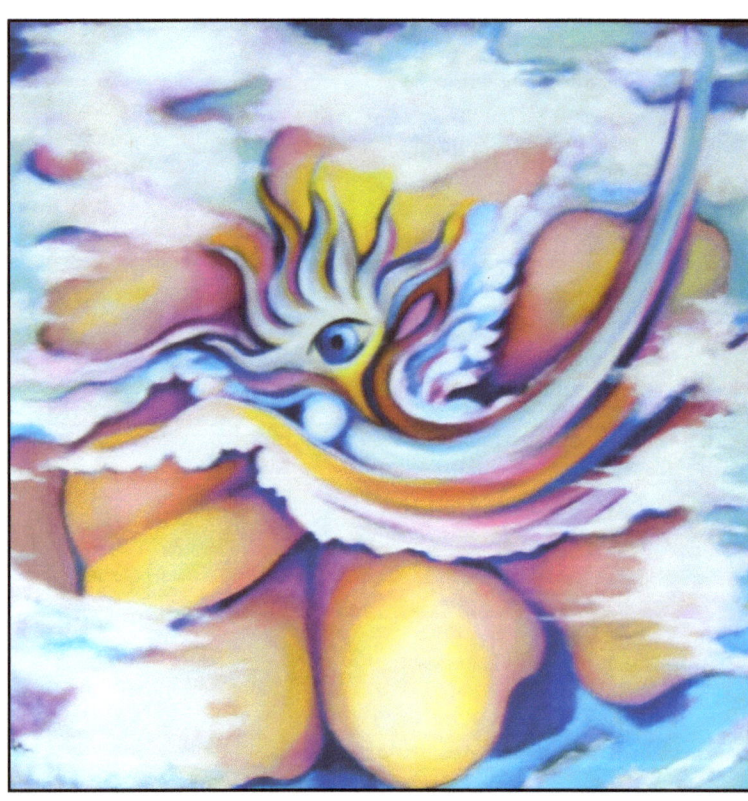

'UNIVERSAL WISDOM"
Oil n canvas 24X24"

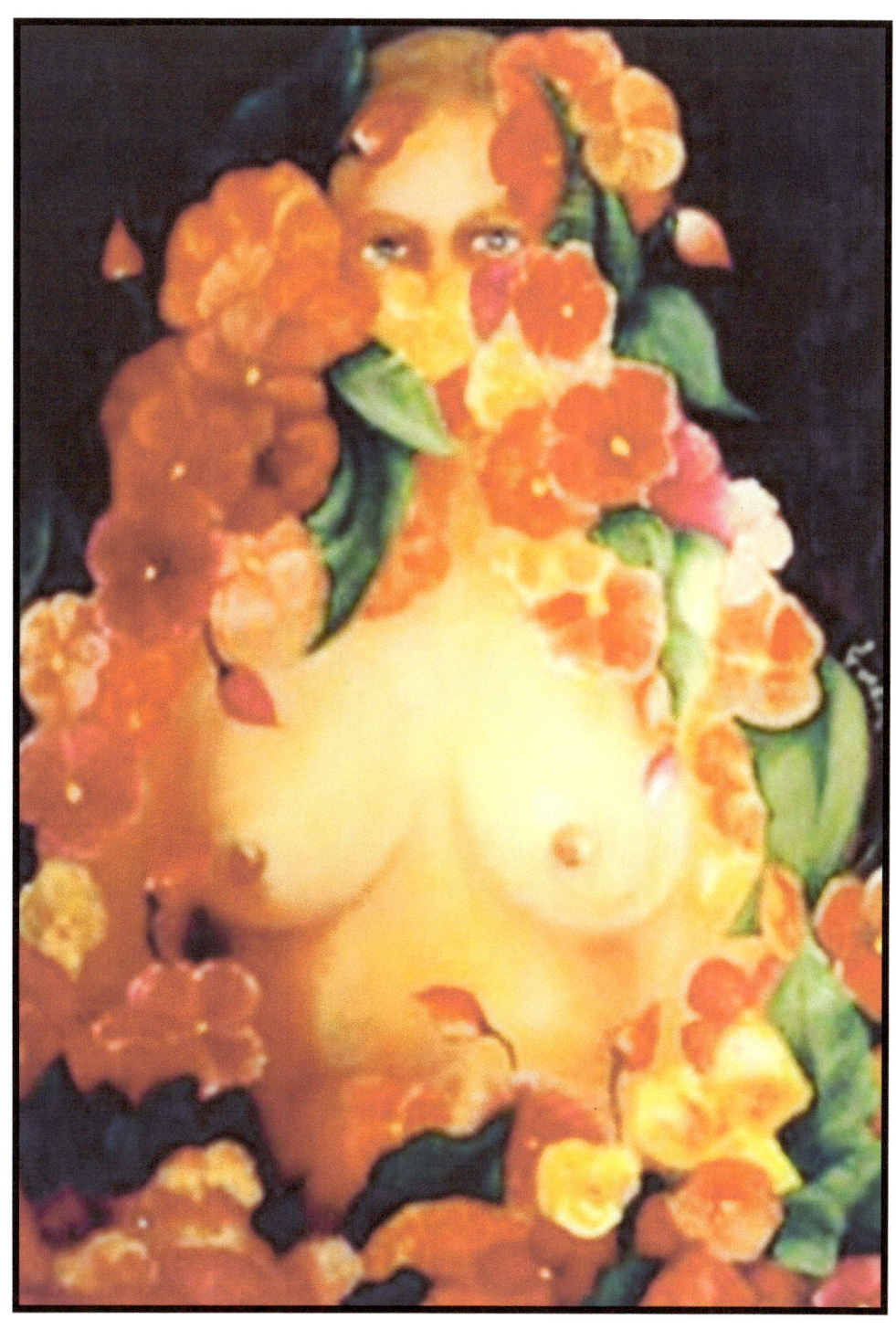

"BLOOMS" Oil on canvas 24X28"
Need I say more?

Jordan and her paintings were on several TV Show. Joe Franklin had her on many times with her psychic portraits. Here she is with Joe at her one woman show opening at the famous Grand Central Gallery in NYC

Don Williams of Chanel 4 TV News filmed a live interview of Jordan in her studio. They also filmed her visual and performing art show at Cinecitta Club to commemorate John Lennon's birthday. John Lennon's portrait "Strawberry Fields" was on show for that entire year. This coverage brought a number of psychic impressionist celebrity portrait commissions. Jordan along with her art has been touted on TV, newspapers, magazines, and even in the famous Cindy Adams column as well as many ART Publications.

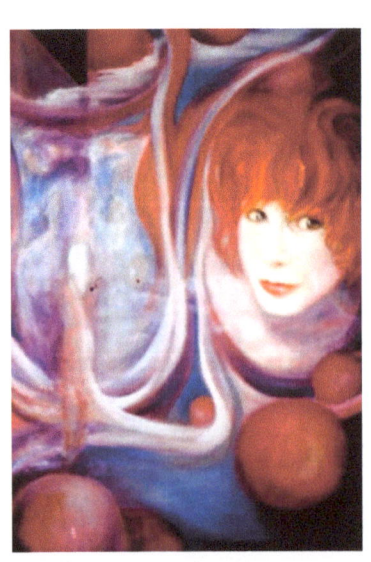

"SHIRLEY INCARNATE"

The talented and vibrant Shirley MacLaine as she contemplates her many fascinating lifetime journeys..

SELECTED GALLERY SHOWS

Genesis Gallery - 57th St. NYC
Grand Central Gallery - 57th St NYC
Nina's Choice Gallery - 57th St. NYC
Dyansen Gallery - Soho NYC
Lombardi Gallery - Soho NYC
Jadite Gallery - NYC
Art Expo - Javits Center, NYC, NY
Zeigler Gallery - Zurich Switz.
Lafayette Gallery - Dallas TX
National Art Sources & Services - NYC
Darell Ramos Gallery - Dallas TX
Guild Hall Museum - East Hampton, NY
Atlantic Bank - NYC
Cristal Bay Gallery - Peekskill, NY
Winthrop Collection - Madison Ave, NYC
Miracles Gallery - Sag Harbor, NY
Marylou's - NYC, NY
Letizia Gallery, NYC, NY
Kazan House of Beauty - NYC, NY
Shagreen Gallery - Savage Mill, Md.
Sundance Gallery, Bridge Hampton, NY
Watchung Art Center, Watchung, NJ
Ryan Chelsea Center NYC, NY
LU MEN Gallery NYC, NY

SELECTED CORPORATE COLLECTIONS

Communications Consulting Corp
Lessin Technology
Breslow & Walker
Ziegler Corp.
Smart Card International
National Communications Association
Association for Information Management
Universal executive Centers
S.A.M. Associates
Interservice
Progressive Ribbon

"I see life as a metamorphosis, an infinity, a cyclical flow of energy. I see the universe as a multi-verse sharing one energy with no beginning and no end. I paint that energy. When I am painting a flower, I am that flower. Sometimes when I paint, I am unaware of what I am painting…...only that I am painting"

Sandra Gayle Jordan

"I studied art at New York's famous **Art Student League.** I studied anatomical drawing with the famous artist *Gustav Rehberger,* through whom, I learned to see as well as sense the life and motion in the human form.

Gary Faigan gave me the structure I needed

Michael Burban gave me the wonderful
 joy and a sense of accomplishment.

 Richard Goetz I learned to see form, colors and composition.

Hilary Holmes gave me a knowledge of the palette and the discipline necessary to paint realism.

Nelson Shanks taught me the difference between sketching and painting a portrait.

Thomas Fogarty and *Oldrich Teply* taught me to see and express freely what I saw and gave me the faith in myself not to doubt my abilities.

The famous abstract artist, *Richard Pousette-Dart* gave me an understanding of abstract thought and emotion. This understanding gave me the freedom to express myself in abstract form on canvas."

As a lifetime member of the League, I cannot speak highly enough of my teachers and recommend the League to all who want to study art.

Jordan has enjoyed an unusually broad and diversified background in the creative arts. Her artistic activities began in childhood, as a dancer, actress and singer. She has performed on stage and screen, and sung in concerts, clubs and on TV in the states as well as abroad. Her repertoire ranges from Puccini to jazz.

During her most active years in the performing arts, Jordan spent as much time as possible on her art work. She designed fabrics, jewelry, sculpted in stone and clay. Her hand painted ties and bottles were sold in several of the chic Madison Avenue Boutiques.

Jordan is mediagenic and therefore no stranger to the media. She has been interviewed by numerous radio and TV talk show hosts as well as having lots of coverage on local and national news programs. The New York Post's famous Cindy Adam's wrote about Jordan in her column and along with numerous other columnists who extolled her abilities, her visionary paintings and illuminating celebrity portraits. Jordan's paintings have been seen in films and TV shows.

Jordan has had numerous art shows in the states as well as abroad. Her works hang in collections around the world. Jordan's psychic impressionist portraits have made her a favorite of the celebrity world and her visionary paintings and impressionist flowers have been shown in New York City's most famous galleries, Jordan was one of the few artists chosen to be represented by the world famous Grand Central Gallery until its close.

"Many of my surreal paintings have come from dreams. Some, a day dream. Some begin as a still life and then morph into some visionary expression. I am often shocked when I see the finished product. A dealer once suggested I was taken over by the spirit of Georgia O'Keefe. Well, not to my knowledge. Though there are times I begin painting a landscape only to wind up with a flower. I start a still life, it turns into a flower. There are times I feel as though someone other than myself has taken over my brush. "

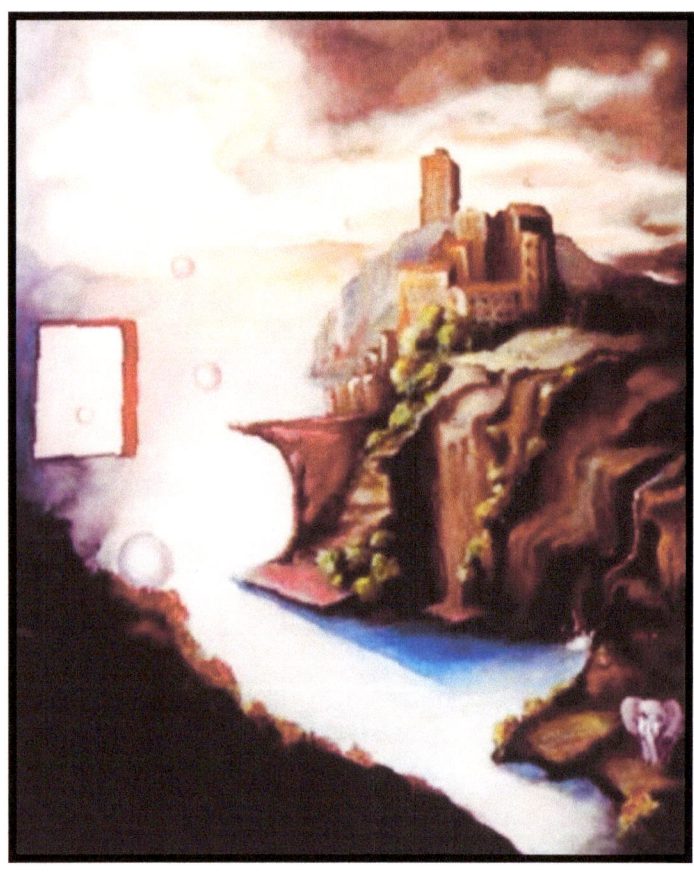

"THE WINDOW" Oil on canvas 24X28"

Here we have souls traveling from one world to the next. Throughout time ad infinitum.

On the other hand, it is fun to copy a painting from an 18th century book.

Many sizes and many styles and fun to do.

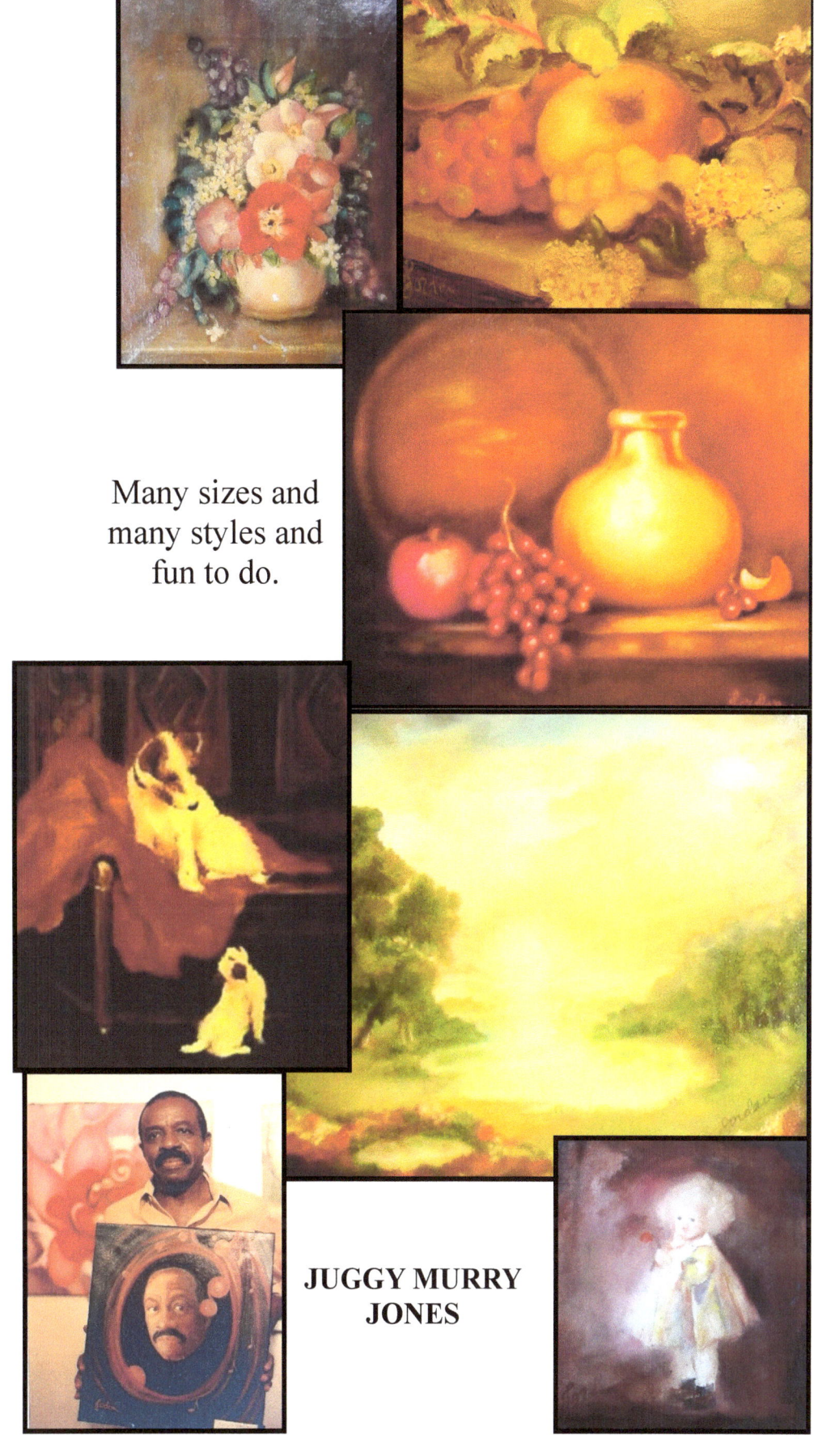

JUGGY MURRY JONES

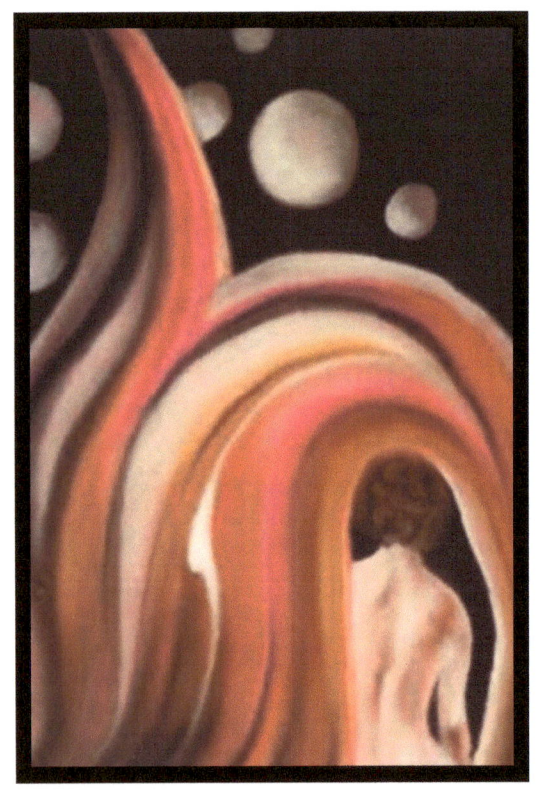

"TODAY IS YESTERDAYS TOMORROW"

www.jordanaco.com
jordanaco@aol.com
Studio: 212 832-7657

www.ingramcontent.com/pod-product-compliance
Lightning Source LLC
Chambersburg PA
CBHW050906180526
45159CB00007B/2803